Palos 6/05

The Life and Art of Adja Yunkers

To invent a garden

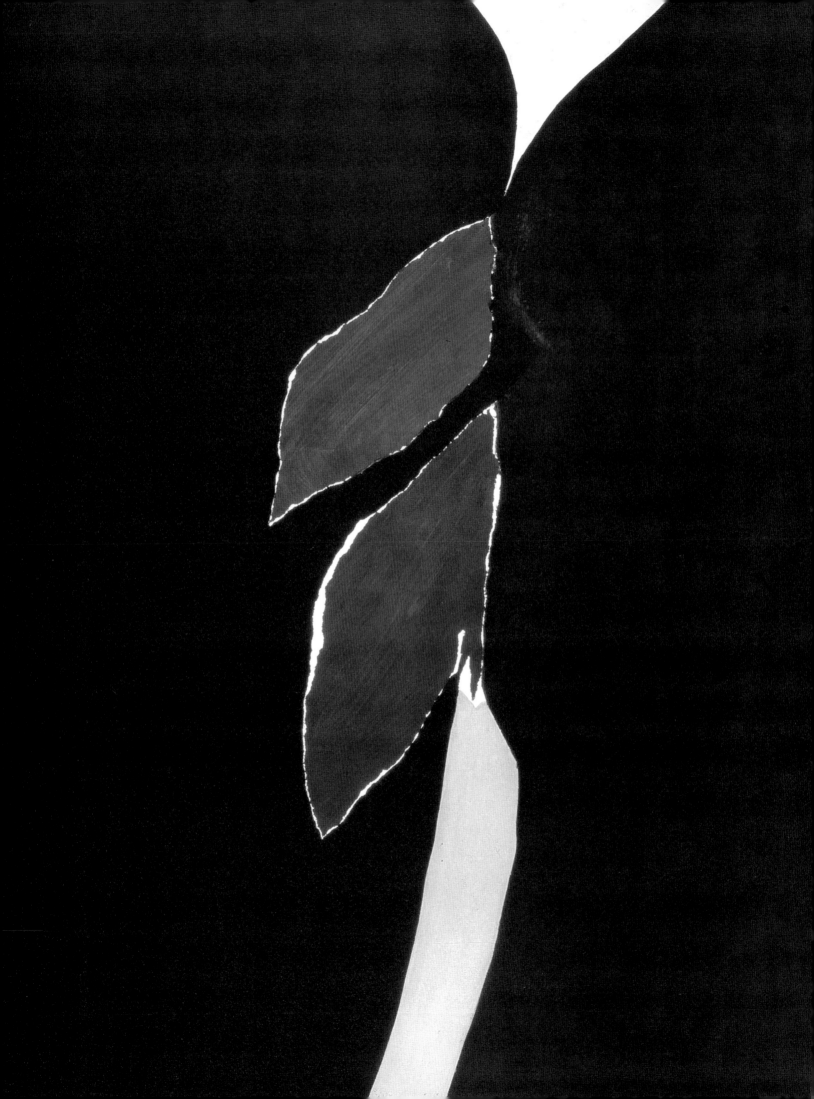

The Life and Art of Adja Yunkers

To invent a garden

Marek Bartelik

Hudson Hills Press, New York

in association with the Bayly Art Museum,
University of Virginia, Charlottesville

First Edition

© 2000 by Bayly Art Museum.
Essay © 2000 by Marek Bartelik.

All rights reserved under International and Pan-American Copyright Conventions.

Published in the United States by Hudson Hills Press, Inc., 122 East 25th Street, 5th Floor, New York, NY 10010–2936.

To Invent a Garden: The Life and Art of Adja Yunkers is published in conjunction with an exhibition held at the Bayly Art Museum, University of Virginia, Charlottesville, from March 21 to June 11, 2000.

Distributed in the United States, its territories and possessions, and Canada by National Book Network.

Distributed in the United Kingdom, Eire, and Europe by Art Books International Ltd.

Editor and Publisher: Paul Anbinder
Manuscript Editors: Sarah Wageman and Virginia Wageman
Proofreader: Lydia Edwards
Indexer: Karla J. Knight
Designer: Susan Evans, Design per se, New York
Composition: Angela Taormina
Manufactured in Japan by Dai Nippon Printing Company.

Library of Congress Cataloguing-in-Publication Data

Bartelik, Marek.

 To invent a garden: the life and art of Adja Yunkers / Marek Bartelik.
 p. cm.
 Exhibition held at the Bayly Art Museum, University of Virginia, Charlottesville, from March 21 to June 11, 2000.
 Includes bibliographical references and index.
 ISBN 1-55595-185-6 (cloth: alk. paper)
 1. Yunkers, Adja, 1900– 2. Painters — United States — Biography. 3. Abstract expressionism — United States. I. University of Virginia Art Museum. II. Title.
ND237.Y86 B37 2000
760'.092—dc21
[B]

 99–54000

Frontispiece: *Homage to the Monks of Vietnam* (detail), 1965–67

Contents

Foreword

As we enter a new century, indeed a new millennium, Adja Yunkers provides a unique bridge between the past and the future. His contributions to the art of the twentieth century span many of the most recognized movements in modernism. His fluency in so many media—from his breathtakingly beautiful and innovative prints and magnificent pastels to his acclaimed artist's books and lyrical abstract paintings—collapses and extends artistic practices. Literally and aesthetically, he was uncontainable and undefinable.

Yunkers arrived in New York at the age of forty-seven, having lived in Latvia, Russia, Germany, France, Cuba, Mexico, and Sweden, and during his long and prolific career he contributed to such important movements as German Expressionism, Surrealism, Social Realism, and Abstract Expressionism. Perhaps this rich transnational mix of cultures and influences is also what makes Yunkers a quintessentially American artist. Twice the recipient of the prestigious Guggenheim Fellowship (1949 and 1954), Yunkers was a prominent teacher at, among others, the New School for Social Research, Cooper Union, and Columbia University. Best known for his Abstract Expressionist work, Yunkers was an exquisite collagist and printmaker—a foremost exponent of the woodcut and pastel media. Admired by his peers, he received the praise of critics, writers, and philosophers with whom he collaborated and who called his paintings "active passion." Possessed with both poetic vision and technical virtuosity, defying classification and fearful of stagnation, he continued to forge new paths until his death in 1983.

Celebrating the centennial of Yunkers's birth, the Bayly Art Museum of the University of Virginia planned this publication in conjunction with the first comprehensive retrospective of the artist's oeuvre since his 1984 exhibition at the Fine Arts Museum of Long Island, in Hempstead, New York. Curated by Marek Bartelik, author of the following essay, the exhibition opens at the Bayly Art Museum in April 2000, after which it will travel to other venues. A New York–based critic, art historian, and adjunct professor at Cooper Union, Mr. Bartelik has conducted extensive research, visiting sites that were influential in Yunkers's life and interviewing family members and friends. He was also given unparalleled access to the works and records in the artist's estate. As a result, both

the exhibition and the accompanying book present new information, enabling us to assess Adja Yunkers's work and his influence and confirming his stature as one of the twentieth century's most creative and thought-provoking artists.

A project of this scale—a major traveling retrospective exhibition and book—is possible only with the expertise and tireless dedication of many individuals. Everyone at the Bayly Art Museum has been involved in one or another aspect of this exhibition for over two years. Under the guidance of curator Suzanne Foley, Rachel Evans, our 1998–99 graduate student intern, and Rebecca K. Young, the 1999–2000 intern, requested and confirmed loans and publication photography and also researched and prepared the biography of the artist. Rarely do students have the opportunity to work so closely and intimately on a major exhibition, and Ms. Evans was a model of diligence, intelligence, and professionalism. Claire Holman Thompson, director of development, was instrumental in helping to raise the necessary funds to realize our vision.

Museums are often hesitant to mount major projects with guest curators, especially those who live hundreds of miles away. If exceptions prove the rule, I have been blessed with an exceptional guest curator. Marek Bartelik has been a pleasure to work with on all aspects of this project, and this publication and exhibition reflect his extensive research and insights.

We have also been fortunate to gain the advice and assistance of an honorary group of advisors—the Yunkers Centennial Committee—composed of Dore Ashton, Yunkers's former wife; Madlain Yunkers, his daughter from an earlier marriage; the art historian Andrew Forge; and Ambassador Donald Blinken. Their support and interest in this project have enriched the results immeasurably. We are grateful to family members, friends, and colleagues, and especially to the artist's estate, for sharing their recollections and records and lending works to the exhibition.

To the museums and private collectors who provided photographs of works for this publication and to the lenders to the exhibition, we also offer our warmest thanks. Such a complete survey of the artist's career would not have been possible without their generosity.

Exhibitions, of course, come and go, and so we are grateful to have a lasting document in which Yunkers's work can be discovered again and again. It has been a pleasure working with Paul Anbinder, publisher of Hudson Hills Press, and his capable staff, including Virginia Wageman and Sarah Wageman, editors, and Susan Evans, designer.

Finally, we thank those whose financial support has been essential to realizing this project on the scale deemed essential for our reappraisal of one of America's

nearly forgotten treasures. The Judith Rothschild Foundation has provided crucial support to the exhibition and publication. Thanks to the generous assistance of an anonymous donor and an endowment established by Ray Graham for the Bayly Art Museum, we were able to collaborate with Hudson Hills Press to ensure that the breadth, beauty, and importance of Adja Yunkers's art would be enjoyed and studied for generations to come.

Jill Hartz, Director
Bayly Art Museum, University of Virginia

Acknowledgments

The author wishes to thank the following institutions for helping him with his research: Albright-Knox Art Gallery, Buffalo, N.Y.; Anderson Gallery Inc., Buffalo, N.Y.; Archives of American Art, Smithsonian Institution, Washington, D.C.; Brooklyn Museum of Art; Cleveland Museum of Art; John Simon Guggenheim Memorial Foundation, New York; Solomon R. Guggenheim Museum, New York; Hamburger Kunsthalle; Hirshhorn Museum and Sculpture Garden, Smithsonian Institution, Washington, D.C.; Kunsthaus, Zurich; Metropolitan Museum of Art, New York; Musée du Louvre, Paris; Museo de Bellas Artes, Caracas; Museum of Modern Art, New York; National Gallery of Art, Washington, D.C.; New York Public Library; Philadelphia Museum of Art; Whitney Museum of American Art, New York; Jane Voorhees Zimmerli Art Museum, Rutgers, State University of New Jersey; Annex Galleries, Santa Rosa, Calif.; Associated American Artists, New York; Frederick Baker Inc., Chicago; CDS Gallery, New York; Dedalus Foundation; Alice Simsar Gallery, Ann Arbor; Syracuse University, N.Y.; archives of the City Hall in Ivry-sur-Seine, France; and the Judith Rothschild Foundation for generously supporting my research with a 1997–98 grant.

The following individuals also generously contributed their time and support: Dr. Eric Baer; Dr. Timothy O. Benson of the Los Angeles County Museum of Art; Ambassador Donald Blinken; Irena Buzinska of the State Museum of Fine Arts in Riga, Latvia; René de Ceccaty; Bruce Checefsky of the Cleveland Institute of Art; Janis Ekdahl, chief librarian at the Museum of Modern Art Library; Rachel Evans, Suzanne Foley, and Rebecca K. Young of the Bayly Art Museum, University of Virginia; Andrew Forge; Barry Garfinkel; Agnes Gund, Dr. Anne Hiltner; Lise Kjaer; Kasia Knap; Ellen Levy; Sarah Mayer; Tad Mike; Carl Fredrik Reutersward; Alla Rosenfeld of the Jane Voorhees Zimmerli Art Museum; George W. Sampson of the University of Virginia; Alice Simsar of Alice Simsar Gallery; Clara Sujo of CDS Gallery; and Boris Tsatlitsky.

Special thanks to Adja Yunkers's family—Dore Ashton, Madlain Yunkers, Marina Yunkers, Sasha Yunkers, and Nina Yunkers—and to Jill Hartz, director of the Bayly Art Museum of the University of Virginia, and Paul Anbinder, president of Hudson Hills Press.

I dedicate this book to the memory of my mother, Regina Marszewska.

Introduction

This is history. You are talking to history, my friend. I've seen every goddamned movement, lived it all.

—Adja Yunkers[1]

Adja Yunkers's rich life spanned almost the entire twentieth century. Latvian by birth and a naturalized American, he lived in seven different countries, went through major personal changes, including five marriages, and witnessed almost all of the major military conflicts that have marked our times: World War I, the October Revolution, World War II, and the Cold War with its offspring, the Vietnam War. Throughout his life Yunkers understood the true meaning of democracy and protested against social injustice. He lived long enough to watch major artistic movements come and go, from Russian Futurism and Suprematism, through Surrealism and Abstract Expressionism, to postmodernism, as the late "mannerist" phase of twentieth-century art has often been labeled. He lived in places designated as "art centers": Petrograd (now St. Petersburg), Berlin, Paris, and New York. However, as much as Yunkers was aware of the new turns politics and art were taking throughout the century, he remained committed to his own artistic expression (or expressive self), and he was uncompromising about maintaining high artistic standards.

Yunkers's biography, especially that of the earlier part of his life, is difficult to reconstruct. As he moved from place to place, he reinvented himself and provided inconsistent information about his past. A few scattered documents and works from the period prior to World War II as well as several long interviews with Yunkers conducted in the 1960s offer insightful but still inconsistent accounts of his early career and life. Nina Yunkers, the artist's daughter from his third marriage (to Lilly Nilsson), once expressed her frustration with the difficulties in re-creating her father's real story: "All and nothing is true in Adja's account of his life."[2]

For most of his life Yunkers considered his origins to be Russian. He had to be aware that such a declaration made a strong political statement for a person who had grown up in Latvia, since at that time most Latvians were struggling to establish their national identity in opposition to the oppressive Russian regime that had occupied their country since 1795. Latvian nationalism led to the country's support of Hitler's Germany during World War II, in response to the country's annexation

by the Soviet Union in 1940. Yunkers was not only fully aware of this nationalist sentiment, but as a radical and intellectual living in exile, he must have strongly disapproved of it. Yunkers's refusal to be considered Latvian may have also come from his separation from his middle class, conservative, and deeply religious family. As an artist and a member of the international community of radical intellectuals, prior to and following his settling in the United States, he indeed lived a different life from the rest of his family, detached from Latvian communities in Russia and abroad.[3] In December 1953 Yunkers became a United States citizen and lived the rest of his life in America.

Yunkers desired to be part of the New York School of Abstract Expressionists, but he seemed to be incapable of becoming a full member of any "school." He was different from most artists in New York, a genuine nomad before nomadism became fashionable and exploited in art. But he refused to capitalize on the status of outsider or nomad, producing art that did not directly address the problems of cultural or social displacement. Unable to fully resolve the identity problems that await a displaced person in an adopted country, he chose to define himself in opposition rather than in relation to the United States. Such an attitude toward the surrounding world, combined with a temperamental nature, did not gain him much admiration among his colleagues in New York, who were struggling to forge their American identities.

Yunkers disliked the term "avant-garde," regarding it as ridiculous.[4] "Every day is avant-garde," he said when he was sixty-eight.[5] Although he was a strong believer in the art of loquacious conversation, he mistrusted theorizing about art. He refused to turn his art into a battlefield of stylistic innovations and remained attached to the idea of art as timeless expression. Yunkers experimented with a variety of artistic media, taking some—notably "traditional" woodcut and pastel—to unprecedented levels. When he felt that he had exhausted a medium, he abandoned it. This was done at the cost of his commercial success, which might have been greater had he been more willing to repeat himself in his art.

Today, Yunkers's re-establishment as an important twentieth-century artist is problematic, for although he is associated with the heroic (predominantly male) ethos of Abstract Expressionism, his art is not recognized as being representative of the movement. In many ways, nonetheless, he embodied the quintessential Abstract Expressionist artist, whose attributes were rejected by subsequent generations of American artists: he was a stubborn believer in the separation of art and life, Eurocentric in his artistic taste, and ultra-male in his dealings with the world. His refusal to succumb to one stylistic formation relegated him to a peripheral status in the eyes of those who write art history based on stylistic consistency. In the vast literature on Abstract Expressionism, Yunkers is absent, or, at best, mentioned *en passant* without any critical consideration. His art does not seem to

provide enough "evidence" for the theoretical considerations that interest most contemporary critics and historians.

Throughout his life Yunkers took great pleasure in reading and writing poetry and collaborated with several poets on various artistic projects. He no doubt would have enjoyed having his life described in a poetic manner, as one that is reminiscent in many ways, on both artistic and personal levels, of the life cycle of a garden. Born in 1900, Yunkers invented his many gardens within the sprawl of the bloom of the twentieth century. As he moved from place to place, reinventing himself both as a person and an artist, his life took on a symbolic cycle of birth, blooming, death, and rebirth. Looking back on his life now, as a new century begins, we are indeed viewing a life experience that "mirrors and condenses the experience of [the twentieth] century and its constant change."[6] We are seeing the history of the last century reflected in the life and art of a man whose artistic passion afforded him major contributions to the world of art.[7]

The Life and Art of Adja Yunkers

To invent a garden

Chapter 1

Early Wanderings

Je suis né le 11/11/11, ce n'est pas vraiment cela la vraie biographie, ce n'est pas le jour où l'on est né, le lieu, la vraie histoire, ce sont les difficultés qu'une personne éprouve à identifier ce qu'on appelle le monde, ses différents moi, les autres, les luttes pour nager à travers ces identités.

—Roberto Matta Echaurren[1]

In a talk delivered at the Corcoran Gallery of Art in Washington, D.C., on November 8, 1967, sixty-seven-year-old Adja Yunkers said, "According to Marshall McLuhan, all personal statements will soon become absolute, swallowed up, as it were, by non-reflecting, non-human mass-media, and therefore I appreciate this occasion in which I have the possibility to expire graciously before becoming absolute." He began by recalling his birthplace:

> I was born on July 15th in 1900, on a Sunday morning, in Riga, Latvia, which, alike with Finland and Poland, formed part of the great Russian Empire and which, after a relatively short period of independence again reverted to, this time, the Soviet Union in 1939, I believe, during the Russo-Finnish war.[2]

Baptized "Adolf Eduard Vilhelm Junker," he was the son of Karl (Karlis) Kasper Junker (1876–1950) and Adelina Federika Junker, née Stahl (1880–1970), both natives of Riga, which remained the family's home until the outbreak of World War I.[3] A vital economic and cultural center, Riga had three distinctive ethnic communities: Latvian, Russian, and German. Yunkers's parents considered themselves Latvian, despite the fact that their names and their social status suggest Baltic-German origins. Karl Kasper Junker worked as an industrial mechanic, providing a livelihood for his wife and three children, Pauline, Bruno, and the eldest, Adja.

Yunkers stated that he left home when he was fourteen years old, in pursuit of his dream to become an artist. It was the first of what would become a lifetime of journeys. He described his reasons for leaving home in the Corcoran Gallery talk:

> I was not a run-away. The reasons were that I had discovered "my call" and my father couldn't or wouldn't see it my way. I had drawn and painted since the age

of seven—imaginary beings, happenings, and also copied old masters from the books I found in my father's library including those of the scantily clad demoiselles of *La Vie Parisienne* to which my father subscribed. . . . One day, in my wandering through Petrograd . . . I was facing a most beautiful building, in my eyes, the facade of which was covered with tiles in cerulean blues and golds! The art school on the Morskaya Street.[4]

He soon enrolled in an art school, which he later referred to as the Imperial Academy of Arts on Morskaya Street.[5] The Imperial Academy, however, was actually located on Vassilevsky Island on the Neva River in a baroque building without the type of rich, colorful decoration Yunkers described in his talk. It is quite possible that Yunkers attended the Drawing School of the Society for the Encouragement of the Arts, which at that time was located on Bolshaia Morskaia Street and offered evening drawing classes that could be attended without an entry examination. (No record of attendance exists owing to the school's open--enrollment policy.) Following in the footsteps of Arshile Gorky (and other émigré artists in America), Yunkers would, in fact, fabricate his credentials in art.[6]

By this time, Yunkers claimed, he had been introduced to Italian Futurism and had read Wassily Kandinsky's book *Concerning the Spiritual in Art*.[7] He stated that his early paintings were inspired by Umberto Boccioni.[8] He also saw the paintings of Kazimir Malevich, which had a lasting influence on him: "My greatest experience as a young man was seeing the paintings of Malevich and the Constructivists," he said.[9] Malevich's abstract Suprematist paintings introduced Yunkers to a new view of the world: "Malevich opened a door, a window to me, so that I was a wide open sore. Everything affected me."[10]

There was a lot to be affected by. World War I intensified the social and political unrest in Russia and led to the October Revolution. Yunkers recalled that during the period of the revolution,

> poets would stop at street corners and start reciting poetry, and in no time at all huge crowds would gather around them and listen—crowds of women, working men, soldiers, prostitutes, and on the fringes people with pale and troubled faces . . . a time in which you would fix artistic manifestoes by painters and poets on the walls amidst government and political proclamations, a time when stepping down into a basement one could hear Mayakovsky and Blok reciting their poetry, accompanied by the song of the machine guns of the mountebank Kerensky, a short-lived political phenomenon. . . . a time you could see the poet Esenin careening madly and drunkenly through the city exhorting the populace . . . the time of horror, excitement, beauty even, a time for young people like me to learn if not very much about art but a hell of a lot about life![11]

In the midst of all of this, Yunkers found himself absorbing Malevich's Suprematist theories:

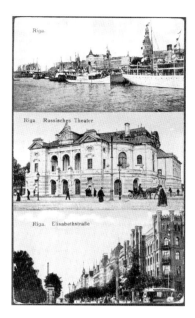

Postcard from Riga from the beginning of the twentieth century.

I felt like a reed swaying amidst all the contradicting events and yet—there was
a great logic involved in all of it . . . there was also the sense of inevitable change
to come—but for the moment I was too busy with Malevich['s] Suprematist
statement that "the visual phenomena of the objective world in themselves were
meaningless and that what counted and had significance was—feeling as such,
quite apart from the environment. The Suprematist does not observe and does
not touch—he feels." Considering the age I was at—to have to make a decision
which would lead me into a country whose geography literally was a *tabula rasa*
for me—to leave the world of will and ideas . . . was fearful, to say the least.[12]

Yunkers stated on several occasions that his early inspiration came from icons, and
icons, in fact, provide an important bridge between Malevich's works and Yunkers's
later pieces, such as *Icon IX*, 1978.[13] Yunkers's earliest documented works, in the
collection of the Hamburger Kunsthalle, show distant affinities with traditional
religious imagery, Russian neoprimitivism, and, in the case of *Untitled (Head of a
Woman)*, 1920 (also Hamburger Kunsthalle), with works of Amedeo Modigliani.
These works do not provide enough evidence to define Yunkers's early style, nor
do they demonstrate substantial knowledge of Russian icons. Still, the artist consid-
ered icons to have been one of his major influences, crediting his uncle Edward
Junkers, who produced religious stained-glass windows, for introducing him to
professional art making.[14] Yunkers could indeed have learned from his uncle how
to create images that were flat and planar with a rich, vibrant palette, which are the
qualities Malevich admired in icons and which later became Yunkers's signature.

"In 1920," Yunkers recalled, "I found myself wandering the streets of Berlin."[15]
At a time when Germany appeared to many to be on its way to turning into a
communist state, Yunkers decided to move there, pursuing his dream of becoming
an artist. Istvan Deak has described the Berlin of Weimar Germany that attracted
artists like Yunkers:

> Berlin harbored those who elsewhere might have been subjected to ridicule and
> persecution. Comintern agents, Dadaist poets, expressionist painters, anarchist
> philosophers, *Sexualwissenschaftler* [sexologists], vegetarian and Esperantist
> prophets of a new humanity, *Schnorrer* ("free-loaders"—artists of coffeehouse
> indolence), courtesans, homosexuals, drug addicts, naked dancers and apostles
> of nudist self-liberation, black marketeers, embezzlers, and professional crimi-
> nals, flourished in a city which was hungry for the new, the sensational and the
> extreme. Moreover, Berlin became the cultural center of Central and Eastern
> Europe as well.[16]

For Russians and East Europeans, Berlin was simply the closest Western metropo-
lis. But like many Latvians and Russians, Yunkers had a highly negative image of
Germans but not without contradictions: "I had come from a country so colorful

in its beauty and cruelty [Russia] that being transferred to this seemingly deadening place came like a shock to me . . . but of course I was wrong because I didn't know better at that time. . . . I was later to discover a different kind of cruelty and despair unknown in my country, or at least, unknown to me."[17]

The picture of Berlin that Yunkers presented in his talk at the Corcoran Gallery did not vary from numerous other accounts that described streets full of unemployed people, widespread prostitution, and an overwhelming sense of growing desperation. But he also was aware of artistic ferment:

> Tucholsky's satires, the merciless drawings and watercolors by George Grosz comparable only to those of Goya etchings. . . . There was the Sturm, called the Sturmgruppe, a gallery [also a journal, a publishing house, and an art school] led by Herwarth Walden who wore a fire-engine red toupee and who at that time was introducing paintings by Chagall, Kandinsky, Picasso, Léger, Derain, the sculptor Archipenko and many others to the German art world. Simultaneously, certain galleries in Berlin were showing German art, the so-called "German Expressionists."[18]

Yunkers remembered being introduced to famous poets and writers during his time in Berlin: Rainer Maria Rilke, Alfred Döblin, and Franz Kafka, as well as the musicologist Hans Hainz Stuckenschmidt, the choreographer and dancer Rudolf Laban, and the art historian and art collector Rosa Schapire, who lived in Hamburg.[19] A month after his arrival in Berlin, Yunkers moved to Hamburg. It is possible that Schapire had taken an interest in Yunkers, and she may have helped him establish the artistic contacts in Hamburg that led to his first solo exhibition at the Maria Kunde Galerie in the early 1920s. According to Yunkers, the exhibition was a success, and it allowed him to rent a studio and pay for trips to Berlin.[20] In Berlin, the dealer and publisher Herwarth Walden introduced him to artists shown in his gallery Der Sturm, including Karl Schmidt-Rottluff, Emil Nolde, and Max Pechstein. At the same time, Yunkers began to participate in group exhibitions with Russian émigré artists including Kandinsky, Marc Chagall, Ivan Puni, and Alexander Archipenko.[21]

Yunkers's early works are quite conventional. His *Untitled (Ich und die Nacht)*, 1920, depicts a man of slender face with piercing eyes, a sensuous mouth, and long hair, drawn with nervous, almost hallucinatory lines and placed against a fragment of a city in the background.[22] In terms of execution, the work appears labored, but the image shows a close resemblance to photographs of the artist from this period. In a photograph presumably taken in Paris in 1925, Yunkers looks like a true "Parisian artist," dressed in a dark jacket, with a silk scarf around his neck and a pipe in his mouth.[23] One detects a certain theatricality in the photograph; young Yunkers was trying to pass for a bohemian, taking for his model the poets Sergei Esenin or Arthur Rimbaud.

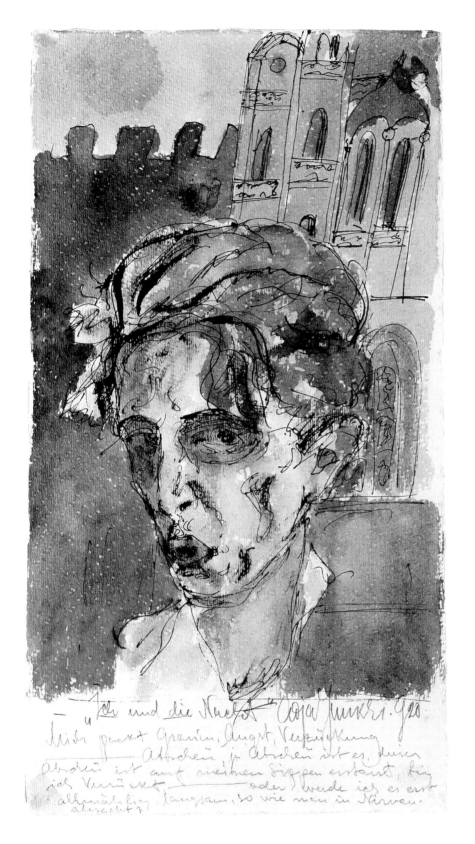

Adja Yunkers in Paris.
Photograph courtesy of Madlain
Yunkers.

Untitled (Ich und die Nacht), 1920,
pen and ink and watercolor on paper,
19¾ × 10⅜ inches.
Kunsthalle, Hamburg.

The painting titled *Me and Hillush*, 1922 (known from a photograph), which depicts a couple dramatically illuminated by a table lamp in front of them, has the ghostly quality of Yunkers's earlier self-portraits. Revealing his familiarity with works of German Expressionists and Chagall, the painting also alludes to the circumstances under which Yunkers met his first wife. An inscription in Yunkers's scrapbook [all scrapbooks are deposited at the Museum of Modern Art, New York] beneath a photograph of the painting reads: "One afternoon in April 1922 I saw my fate in profile. I had been smoking opium and died. Then I was brought back to life by my future bride."[24]

The "future bride" to whom Yunkers referred was Hildegard Kutnewsky, whom he would later marry in Hamburg in April 1925. Madlain Yunkers, daughter of Yunkers and Kutnewsky, tells the story of her parents' meeting in 1922, when one of her mother's girlfriends telephoned Kutnewsky (then a newly licensed doctor) "to beg her to come and treat her boyfriend [Adja] who had passed out from an overdose [of opium]. Mother revived him by packing him in ice and hot compresses for many hours. When he came to, so the story goes, he fell in love with her Titian hair, and she with his slender body and handsome face. There was much opposition to a young Jewish doctor being involved with a poor artist and 'foreigner.'"[25]

This opposition may have contributed to Yunkers's being expelled from the country when he applied for citizenship before the City of Hamburg Council in 1922. Madlain Yunkers recalls, "My aunt's second husband, a prominent fur trader, reported him as an ex-addict, a 'revolutionary,' and a man living under an assumed name."[26] Forced to leave Germany, Yunkers went to Italy, where he met the critic Bernard Berenson at his villa I Tatti (Yunkers remembered that Berenson read Tolstoi to him in Russian, a language that Berenson knew well). In Florence he met Carlo Carrà and Herminia Zur Muenlen, artists associated with the magazine *Valori Plastici*.[27]

This was the beginning of a period of great exploration in Yunkers's life. Between 1922 and 1930 he lived in and visited a number of countries, among them Italy, Germany, Spain (including the Canary Islands), France, and Cuba. Leaving Italy in 1922, Yunkers returned to Germany briefly, where he boarded the steamship *Antonio Delfino* on its way to Spain. Arriving at Vigo, he immediately headed for Madrid.[28] While he was in Spain, his nomadic life derived its stability from art:

> I made my way through Spain visiting Toledo and El Greco's *Burial of the Count d'Orgaz* . . . to see the mysterious rocks of Castile and of Aragon . . . visit Barcelona, the Ramblas [the boulevard in the center of Barcelona] and the museums and look at the wonders in the garden built by Antoní Gaudí, and at the Catalan Gothic! I am pleased to say that already then I saw the magic of Gaudí whose genius would become known widely only in the late 1950s as a result of the revived interest in Art Nouveau.[29]

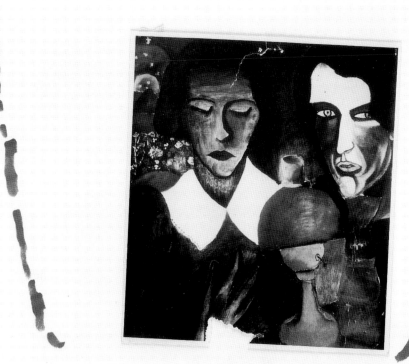

A DOUBLE PORTRAIT OF ME AND HILLUSH MY FIRST
SERIOUS LOVE IN GERMANY • I WAS THEN XXX 22 YRS OLD —
AND I WAS STILL LOOKING FOR MYSELF — HENCE THE
CHAGALL'ESQUE STYLE • AN INFLUENCE WHICH DIDN'T LAST •

ONE AFTERNOON IN APRIL 1922 I SAW MY FATE
IN PROFILE

Paul Klee, *The Barbed Noose with the Mice*, 1923, watercolor and gouache on cardboard, 9 × 12⅛ inches. Metropolitan Museum of Art, New York, Berggruen Klee Collection.

Yunkers's scrapbook contains a union book from the Danish freighter *Haderslev*. It states that Yunkers, employed on the ship as a stoker, sailed to Africa on February 2, 1924, returning to Las Palmas, Canary Islands, in March 1924. From the Canary Islands he tried to get back to Germany as a stowaway on a German commercial ship, but he was discovered and thrown off in Las Palmas.[30] He finally was able to leave Las Palmas, arriving in France later in 1924.[31]

In Paris, Yunkers supported himself with manual labor, visiting art museums as often as he could. "I settled down in Paris in a little hotel room near the Gare Montparnasse on the avenue de Maine.... After I had deposited my bag in my room I went out and straight to the Louvre to make my homage to it, and passing the Gioconda I smiled back at her, winking one eye at her."[32] Art and artists continued to offer the point of reference that brought stability to Yunkers's erratic life.

In his talk at the Corcoran, Yunkers mentioned returning to Germany in 1924 (this time to Dresden) and finding himself in Arnold Böcklin's studio in which the German artist had painted his famous *Toteninsel (The Island of the Dead)*, about 1880. It was during his time in Dresden that Yunkers was first introduced to the work of Paul Klee, another artist who played a major role in his life and whose works, such as *The Barbed Noose with the Mice*, share affinities with Yunkers's art from that period:

> My first encounter with Paul via a stack of about 100 watercolors and drawings was at the home of Will Grohmann in Dresden in the mid-twenties. At that time he was a schoolteacher and about to write the first comprehensive book on Paul Klee. Will Grohmann became a most eminent person in the art world. This meeting with Grohmann and the Klees made a soul [*sic*] lasting impression on my young and thirsty [missing words], as unforgettable as the dinner. He served a huge bowl of white asparagus, white bread with ice-cold butter and exquisite white Rhine wine. [The drawings] Klee had made in Morocco, Marrakech, etc., still haunt me and I will not rest until I get to Marrakech and can follow his lines.[33]

Shortly after marrying Kutnewsky, Yunkers returned alone to France. By January 1926 Yunkers was sailing to Cuba, possibly encouraged by a number of exiled Cuban intellectuals who lived in Paris in the mid-1920s, where they formed the informal Grupo de Montparnasse and later returned to their country as militant modernists. Kutnewsky-Junkers joined her husband in Cuba but returned to Germany to give birth to Ines Ruth Madlain Yunkers in February 1927. In Cuba Yunkers changed the spelling of his name from Junkers to Yunkers, which was easier to pronounce in Spanish.[34]

Photographs of Yunkers from Cuba convey an image of a different artist from the Parisian bohemian: he is well dressed in a suit, white shirt, necktie, and hat. His wife appears in several pictures wearing elegant dresses and hats and holding an

umbrella or fan. There is a sense of stability and joy in these photographs.[35] Two of Yunkers's watercolors (known from photographs taken in Cuba), a portrait of his wife and a double female nude, also convey a sense of tranquillity and relaxation. Executed in a style that recalls works by such artists as Modigliani and Paul Delvaux, they share the simplicity, grace, and directness of the advertisements that Yunkers produced around this time.

Yunkers worked as a commercial artist while he was in Cuba. An employment document dated May 4, 1927, states that from January 17, 1926, until April 30, 1927, Yunkers worked as a manager of Window Display and Advertisements for the Artistic Department of a large store in Havana called La Casa Grande on Avenide de Italia. His advertisements for La Casa Grande demonstrate an impressive command of the graphic style and commercial language that appealed to the Cuban clientele hungry for "Parisian" splendor.

Yunkers was, however, more innovative in his works apart from La Casa Grande assignments. A February 1927 illustration published in the program for a concert directed by the composer Amadeo Roldan and the writer (and music critic) Alejo Carpentier, featuring the singer Lola de la Torre, is executed in a sinuous, arabesque line that recalls La Casa Grande advertisements, but the two musicians are imbued with a more Léger-like "modernist" presence, with their volumetric bodies mimicking the shape of their cellos. Yunkers wove the words "Musica nueva, audicion, 27 Ferbero" into the drawing, so that the two musicians form a semiabstract image, like a musical score.

Yunkers produced his first print, the color woodcut *Nañigos*, in 1927, while he was in Cuba.[36] *Nañigos* depicts the secret ritual of sacrificing a cockerel. The title refers to a sect from Nigeria that had numerous followers among the Cubans. The rituals were performed by masked dancers and involved both human and animal sacrifice. Yunkers's work shows a crowded space with a frightened bird jumping in the air and three hooded human figures in African *diablito* costumes and dancelike poses. One of them holds a pitcher in his left hand as in a bacchanal, while the others hold bunches of flowers or leaves that look like whips. *Nañigos* exhibits a high degree of stylization and pattern design indicative of Cuban folklore. To execute the picture, Yunkers clipped a photograph of a cockfight from a Cuban newspaper.[37]

Nañigos also strongly recalls Russian *lubki* (popular folk prints), both stylistically and iconographically. Early *lubki*, such as *Spin, My Yarn Spinner,* were mostly crude, sometimes humorous copies of icons and book illustrations that often combined image with verse, a practice that later extended to the illustrations of *skazki,* Russian folk and fairy tales, familiar to Russian children. (Yunkers would return to the practice of combining images and text in his later prints.) As *lubki* became more secularized, they often depicted violent episodes in Russian history

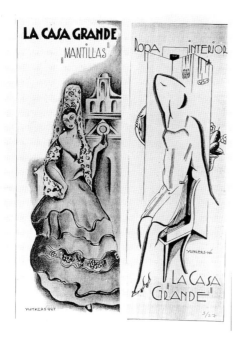

Advertisements for La Casa
Grande, Havana.
Estate of Adja Yunkers.

Nañigos, 1927, color woodcut,
13½ × 10¼ inches.
Frederick Baker Inc., Chicago.

and daily life.[38] In *Nañigos,* Yunkers combined the tradition of Russian *lubki* with Cuban influences derived from a new local sensibility.

The interest in Afro-Cuban rituals among Cuban artists was part of their search for national identity. The writer Giulio V. Blanc has described Cuban artistic life in the 1920s, a milieu that stimulated Yunkers:

> Organized in 1923 and made up of young writers, artists, and intellectuals, the Grupo Minorista was the catalyst for a profound change in Cuban culture, one that emphasized Afro-Cuban and folkloric contributions and led to their serious treatment with works of art, literature and music. European—especially Parisian—modernism was a motivating factor in this cultural renaissance, as was the example of Mexico and its government-sponsored muralists, who documented the pre-Columbian and folk heritage of their country.... A number of key events served to underline the growth of what became known as *afro-cubanismo* as well as related approaches to cultural nationalism.... In 1925, the composer Alejandro Garcia Caturla wrote his *Danza lucami,* and Amadeo Roldan created *Obertura sobre temas cubanos.* The year 1927 was a watershed in this process of creating a national ethos. The *Revista de Avance* (1927–1930), organ of the Minoristas, began publication. It included fiction and essays by avant-garde writers from Cuba and elsewhere and debated issues such as "What constitutes Latin American Art?" A leader of the avant-garde, Alejo Carpentier, pursued his interest in Afro-Cuban culture and, in 1933, published his novel *Ecue-Yamba-O.*[39]

Carpentier, whom Yunkers knew well in Cuba, responded to the 1927 discussion on the issue of Latin American art: "It is difficult for a young [Latin American] artist to think seriously of creating pure art or dehumanized art. The desire to create a native art conquers all wills... our artist finds himself forced to believe, a little or a lot, in the transcendence of his work."[40] As a member of the artistic community in Havana, Yunkers shared with Cuban artists their interests and dilemmas. In an unpublished interview with Aldo Menendez, Carpentier praised Yunkers for having a great influence on young Cuban artists in the late 1920s.[41] After Yunkers's death, when Dore Ashton met with Carpentier's widow in Cuba in the 1980s, the Cuban poet's wife remembered Yunkers well and called him a great Cuban artist.[42]

In his Corcoran Gallery talk, Yunkers confirmed that the period in Cuba was one of relative peace and concentrated work. *Blooming Cactus,* 1926 (collection of Madlain Yunkers), is one of Yunkers's few surviving works from the Cuban period. The watercolor depicts a bulbous, leafy cactus in a blue pot standing in an open window through which night stars are seen. In his scrapbook, Yunkers preserved artifacts from that adventurous period: several handwritten poems by Dulce Maria Loynaz, a Cuban Symbolist poet with whom he claimed to have had

Russian *lubok*, *Spin, My Yarn Spinner,* 1869, lithographic transfer from engraved copperplate, 13½ × 17⅛ inches. Jane Voorhees Zimmerli Art Museum, Rutgers, The State University of New Jersey, The George Riabov Collection of Russian Art Donated in Memory of Basil and Emilia Riabov.

an affair.[43] In 1927 Yunkers was forced to leave Cuba because of the growing persecution of leftist intellectuals by President Gerardo Machado.[44] His friend Carpentier, after being jailed for forty days in 1927, used the French writer Robert Desnos's papers to leave Cuba for a self-imposed Parisian exile in 1928. Yunkers went to Mexico, escaping—as he said—the political persecution launched against leftists.[45]

In what was by then a succession of encounters with famous artists and poets, Yunkers said he met muralist Diego Rivera in Mexico:

> Upon arrival in Mexico City I made my way to Diego Rivera's home. It was one of the first Corbusier-style houses in Mexico City, surrounded by huge cacti, which served as a fence. . . . I went into the house and wandered around without finding anyone at home until I happened to open a door to a bedroom and there was a huge bed and in the middle of it, between two large, nay—immense— pillows was lying a baby; on the one side of the baby. . . I saw a cannon of a revolver lying. . . . I knew then that I indeed had arrived in Mexico.[46]

Yunkers remembered spending days with Rivera discussing art and politics and meeting other Mexican painters, among them José Clemente Orozco and David Alfaro Siqueiros. Then, as unexpectedly as before, Yunkers packed and returned to Europe.

Chapter 2

The First Woodcuts

...and so we came to 1927 with very significant events to note, such as: Trotsky and Zinoviev being excommunicated from the Communist party in Russia, the year Sacco and Vanzetti are executed, the surrealists are making overtures to the Communist party in France, the first talkie appears in the U.S.A.: "the Jazzsinger" (with Al Jolson), Heidegger's Etre et temps *is published, a civil war is raging between Tschang-Kai-chek and the communists in China, Elie Faure publishes* L'Esprit des formes, *Paul Valery is elected to the French Academy, and [it] is the year of the foundation of the anarchist internationale and last but not least; Lindbergh crosses the Atlantic!*

—Adja Yunkers[1]

By late 1927 or early 1928, Yunkers was back in Hamburg, then he went to Berlin, where he was trying to renew the contacts with artists and critics he had established earlier that decade.[2] In November 1929 an article on Yunkers appeared in *Monde,* the French review that was published by Henri Barbusse, the revolutionary modernist writer and communist activist.[3] The article was accompanied by two woodcuts by Yunkers, one titled *Travail des Champs* (Work in the Fields), the second untitled. *Travail des Champs* depicts a tractor plowing a field with the driver looking straight ahead. There are in fact two tractors and two drivers, but it looks as though one is a mirror image of the other. The field covers the entire picture with the exception of a triangular upper corner, which is filled with a shining sun. The untitled print ventures into a primordial stage of fields before the age of machines, depicting two Pegasus-like horses in poses that suggest sexual intercourse in a field bathed by the sun's rays. Its expressiveness is reminiscent of German and French modern art, but the monumentality of scene (despite the small size of the image) recalls works by the Mexican muralists. Yunkers would successfully use the same formal combination in his later woodcuts.

Yunkers divorced Kutnewsky-Junkers in 1928 and moved to Paris in 1930. He told a reviewer that he had met Barbusse in the Luxembourg Garden in 1930 and that Barbusse helped him to obtain a commission for painting several large murals in Ivry-sur-Seine, a suburb of Paris with a communist government. Although it is possible that Yunkers submitted his proposals for the murals, the records of the City Hall, where the murals were supposedly painted, do not support the claim

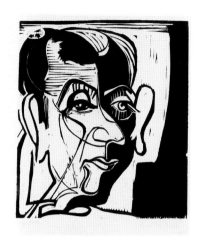

Ernst Ludwig Kirchner,
Portrait of Jean (Hans) Arp, 1933,
woodcut, 13⅞ × 12½ inches.
Philadelphia Museum of Art,
Curt Valentin Bequest.

that the murals existed. The artist Boris Taslitzky, who lived and worked in Ivry in the 1930s, remembers that "the local government in Ivry used to organize festivals for children [*grandes fêtes*] in June . . . and for the July 14th. The importance of the last one was conferred by the national policy of the French Communist Party (whose general secretary was a deputy from Ivry) and the menace of Nazism."[4] Taslitzky does not recall Yunkers, but he points out that public commissions in Ivry had a temporary character.[5] Perhaps Yunkers executed murals in Ivry for a specific occasion and they were simply removed or covered by other paintings, for Yunkers remembered his work on them vividly: "I worked [on the Ivry murals] for a whole year. The workers would sit down at lunchtime and open their lunch boxes and [have] their wine and chocolate and white bread. . . . The painting was all very realistic and figurative." He described the murals' content as "a big satire on bourgeois society" with "real portraits": the poetess Anna de Noailles, Jean Chiappe (the local chief of police, known for his extreme right-wing views), and workers reading Karl Marx and Alfred Dreyfus [*sic*].[6]

Most of Yunkers's known works from the late 1920s and early 1930s are prints. It is quite clear that by this time he was inclined to create works of art with strong social content. A series of woodcuts with evocative titles—*Birth*, *The First Murder*, *The New God*, *Earth* (reproduced in *Monde* as *Travail des Champs*), and *War*—probably made in Germany in the late 1920s—follows in the footsteps of political and social satires by Grosz, Otto Dix, Max Beckmann, and Oskar Kokoschka.[7] Yunkers's prints reflect German Expressionists' interest in religious iconography and images from the war. *Birth* and *The First Murder* contain biblical references, to the stories of Adam and Eve and Cain and Abel, respectively. *War* shows a man in uniform, dripping with blood and holding a hand grenade; his look of desolation and despair is matched by the barren landscape with trees and houses burned to the ground. It is both an apocalyptic and a visionary image, showing the destruction caused by World War I and signaling another war to come. The influence of German Expressionism is further evident when a later, undated self-portrait drawing by Yunkers is compared with Ernst Ludwig Kirchner's woodcut *Portrait of Jean (Hans) Arp*, 1933.

Around the same time, Yunkers produced in Paris a set of eleven woodcuts on the theme of social injustice toward workers titled *The Ten Commandments*. The prints were distributed by the Anarcho-Syndicalists in Stockholm in the mid-1930s.[8] They depict scenes from daily lives of workers experiencing hunger, desolation, and anger. In one of the images, a policeman grabs a man writing "Du Pain, Du Travail" (some bread, some work). The print titled *You Shall Not Take the Name of the Lord in Vain* depicts an obese man sitting on the shoulders of a smaller man placed against a view of a factory. The fat man represents a bourgeois or capitalist as traditionally caricatured by leftist artists all over the world. The prints were signed "A.Y. Robot"—a proletarian version of an automaton.

Self-Portrait, n.d., pencil on paper,
8½ × 6½ inches.
Estate of Adja Yunkers.

I DISCOVERED THESE WOODCUTS CUT IN PARIS DURING THE
MID-AND LATE TWENTIES AND EVENTUELLY DISTRIBUTED BY THE
ANARCHO-SYNDICALISTS IN STOCKHOLM, SWEDEN WITH AN INTRO
BY A GREAT SWED. POET, MEMBER OF THE ACADEMY AND NOW DECEASED;
HARRY MARTINSON —THEN A FRIEND AND INSPIRATION •

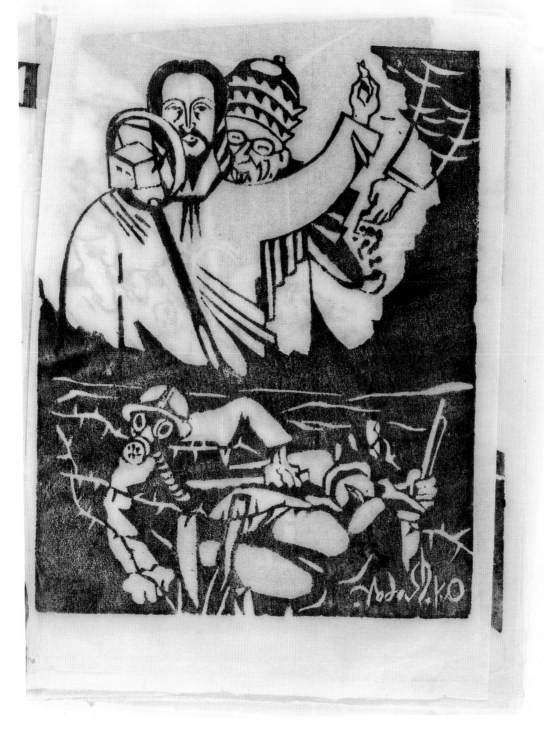

Woodcut from the *Ten Commandments*
series, photograph from a scrapbook.
Museum of Modern Art, New York.

Alphabet drawing, 1930, watercolor and pencil, 4⅝ × 4⅝ inches. Courtesy of Madlain Yunkers.

In the early 1930s Europe was in the wake of a new war, and the war against so-called "entartete Kunst" (Degenerate art) had already started. Many artists, such as Kandinsky and Klee, left Germany by 1933. In those turbulent times, political events—such as the crash of the stock market in New York and the suicides of Esenin and Mayakovsky—easily took on symbolic significance. Yunkers briefly returned to Germany in 1933 and tried to convince his ex-wife to emigrate. Madlain Yunkers's earliest visual recollections of her father are connected to that period; they are images of Mickey Mouse and other Disney characters that her father painted on the walls of her room in Hamburg.[9] Another pictorial souvenir from that period is a set of small, humorous illustrations for letters of the alphabet, executed in early 1930 in the style of images in Russian children's books by such artists as Ivan Bilibin and Vladimir Lebedev. Kutnewsky-Junkers and her daughter finally left Germany for Spain in 1934, by which time Yunkers was living in neutral Sweden.

Sweden was a good place for Yunkers, who with his foreign passport and artistic profession was not welcome in more chauvinistic Germany or France. Artistically, however, Sweden was quite provincial. The historian Pontus Hulten writes:

> In Sweden, the thirties was a rather bleak period. . . . From the beginning of the decade an artist cooperative called "Color and Form," representing a romantic, sometimes expressionistic naturalism of a rather nationalistic (or provincial) kind, more or less totally dominated the market. After the immediate postwar period, some younger artists started to show rather timid non-figurative work based on formal ideas coming from the Bauhaus vocabulary and inspired by the play of positive-negative forms in the Guernica structure.[10]

During his early years in Sweden Yunkers was associated with the Swedish Anarcho-Syndicalists (among them the poet Harry Martinson), crediting them

for helping him the most with settling in Stockholm. He joined the Anarcho-Syndicalist Party and began to contribute to its publications by reprinting *The Ten Commandments* and making portraits of the famous anarchist leaders Mikhail Bakunin and Piotr Kropotkin.[11] Yunkers frequented the house of Alexandra Kollontai, the feminist, Marxist, close friend of Lenin and mistress of Mussolini who lived in Sweden from 1930 as a minister and ambassador of the Soviet Union and kept a salon for actors, musicians, artists, and politicians.[12] Yunkers remarried in late 1933, this time to Märta Fernström, and in 1935 the couple had a son, Mikael.

In 1936 Yunkers traveled to Barcelona, where he saw Picasso's new works that were being exhibited at the Sala Estreva in Barcelona. A few drawings and prints from Spain reveal his interest in the exhibition, which included Picasso's images of the Minotaur and the bullfight. Yunkers's Spanish drawings and sketches of female nudes and couples engaged in sexual intercourse are like notations on Picasso. Without making overtly political art, which mostly required the language of Socialist Realism, Picasso was able to convey the menacing aspect of life prior to World War II and leave a powerful testimony of that extremely turbulent period, setting standards for other artists who rejected Socialist Realism. An untitled small print from Yunkers's Spanish period (collection of Dore Ashton) represents a Picassoesque elongated female figure trapped by coils around her torso, her mouth gagged with what looks like a musical instrument. The print was executed with two blocks, as Yunkers decided to add a second color (orange) to emphasize the almond-shaped sun in the upper-right corner.

Yunkers's woodcut *Death of the Minotaur*, ca. 1936 (Estate of Adja Yunkers), focuses on a wounded beast in agony with a spade and three spears dangling from its body. The work is executed in brown ink on a red background and printed on thin wax paper. Later, in a 1944 illustration he produced for *Dikter Mellan Djur och Gud* (Poems between Animals and God), published in collaboration with the poet Artur Lundkvist in Stockholm, Yunkers returned to the highly erotic Minotaur theme that had had a profound effect on him during his trip to Spain. Yunkers's 1944 illustration is executed in a sinuous, nervous line that recalls *Minatauromachia*, one of Picasso's etchings from the *Vollard Suite*, 1930–37. Discussing Picasso's approach to the Minotaur theme, art historian Herschel B. Chipp underscores its appeal to many artists in the 1930s:

> The part-man, part-bull being—or Minotaur—was favored by the surrealists and by Picasso, who while scorning the dogma of Surrealism still felt himself instinctively attracted to the Minotaur's fusion of love and hate, eroticism and repulsion, and divinity and bestiality. The Minotaur, furthermore, symbolized for artists and poets alike the Freudian unconscious drives that subverted conventional behavior.

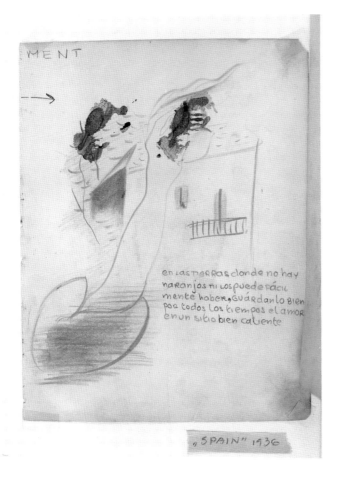

en las tierras donde no hay
naranjos ni los puede fácil
mente haber, guardan lo bien
por todos los tiempos el amor
en un sitio bien caliente

„SPAIN" 1936

Page from a scrapbook with
a drawing from Spain.
Museum of Modern Art,
New York.

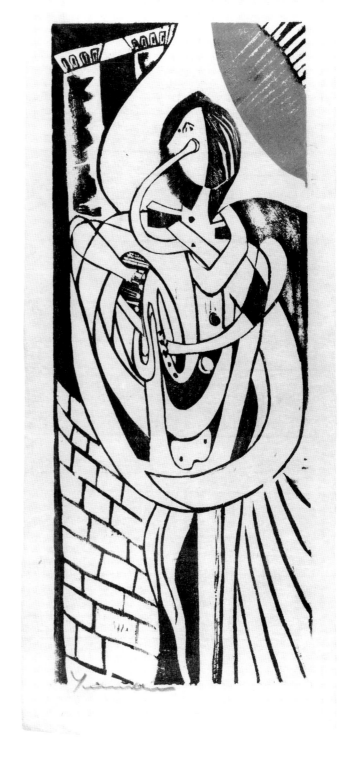

Untitled, mid-1930s, color woodcut,
$13\frac{1}{2} \times 5$ inches.
Estate of Adja Yunkers.

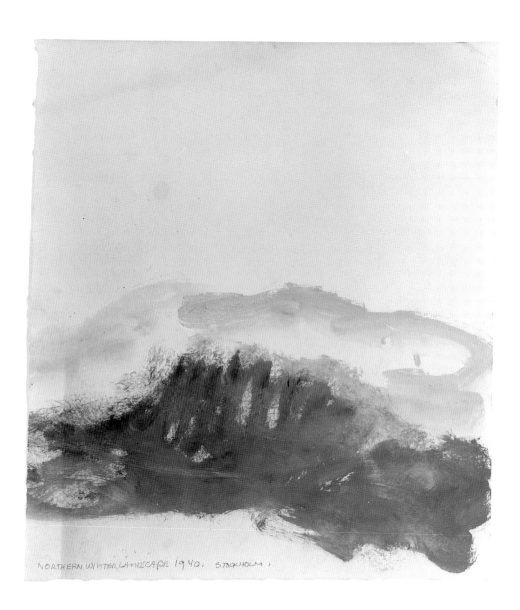

NORTHERN WINTER LANDSCAPE 1940, STOCKHOLM,

Although never willing to submit to André Breton's authoritarian leadership of
the surrealist group, Picasso was drawn to the potentialities of the Minotaur as
a symbol of unbridled passions. Thus it came about that the combined brute
violence and artistic ritual of the Spanish corrida were fused with the partially
concealed erotic imagery of the human unconscious to form the ambivalence of
the Minotaur.[13]

Returning to Sweden later in 1936, Yunkers divorced Fernström and married for
the third time; his new wife was the Swedish singer and journalist Lilly (Lil)
Nilsson.[14] Yunkers and Lil had a daughter, Nina, born in 1939. By this time
Yunkers's ties with the Swedish Anarcho-Syndicalists were weakening, and soon
after his new marriage, following his wife's advice, he began to distance himself
from the anarchist movement.[15]

The Shoemaker, 1951,
color woodcut, 28¾ × 16¾ inches.
Estate of Adja Yunkers.

Chapter 3

Printmaker in America

I remember when I came over here somebody was writing a biography about me and asked me, "What is your history?" I said, "I don't have any history. I just started here."

—Adja Yunkers[1]

In his application for a 1949 John Simon Guggenheim Memorial Foundation Fellowship, Yunkers wrote: "I came with my wife to the United States on the 1st of June 1947 on a non-quota immigrant visa to begin my work as a teacher at the New School for Social Research in New York City. I immediately applied for citizenship as I intend to remain in this country permanently."[2] Yunkers's beginnings in America were auspicious. His 1946 show at the New School had already received a number of enthusiastic reviews, including one written by Josephine Gibbs in *Art Digest:*

> Completely unheralded—the N.S.S.R. [New School for Social Research] is introducing a Swedish [*sic*] artist, Adja Yunkers, with the most extraordinary group of color woodcuts that . . . don't look like prints, but like richly pigmented oils on paper, overlaid with glazes. . . . Little wonder that Yunkers is already represented in the collections of the Museum of Modern Art—the Metropolitan—Boston and Fogg Museums, and that of Lessing J. Rosenwald.[3]

After he moved to the United States, Yunkers began to be included in various group exhibitions, while major private collectors and public institutions were actively buying his prints. He frequented the Surrealist circle around the magazine *Tiger's Eye,* lavishly published by Ruth and John Stephen in 1947–49. This short-lived publication contained poetry, anthropological studies, and reproductions of works by, among others, Gorky, William Baziotes, Max Ernst, and Mark Rothko. In June 1949 the magazine published an article on Yunkers in which he discussed printmaking techniques.

When Yunkers applied for the 1949 Guggenheim Fellowship, he wrote that he wanted the grant "to be able to continue with my artistic research work in the field of color woodblock printing and recommence my book." Drawing on his experience as a printmaker, Yunkers intended to write a book on modern woodblock printing. He explained:

> When I started the study of modern woodblock printing in 1942, my intention was, and still is, to describe and analyze the rise and fall of woodblock printing with the accent on the rediscovery of this old medium of creative expression by Paul Gauguin, Edward [sic] Munch and the German Expressionists in the twenties, and how this depended on the underlying social structure of Europe, specifically Germany, at the time. To analyze the factors which accounted for a great period in woodblock printing in the past and to show to what extent these factors have been the vehicle of great achievements in modern woodblock printing in the United States. . . . In short, to end the general conception of the woodcut being an inferior form of art, and to prove that woodblock printing today is an autonomic form of art with its own well defined rights.[4]

Yunkers was recommended for the fellowship by an impressive group of professionals: Bryan J. Hovde (president of the New School for Social Research), the curators Paul Rosenberg, Carl Zigrosser, and Carl O. Schniewind, and the art collector Lessing J. Rosenwald. Rosenwald had earlier helped Yunkers and his wife obtain their visas, when upon their arrival in Baltimore their passports were not accepted by border officials. Yunkers was awarded a Guggenheim for 1949–50.

In the summer of 1948 Yunkers had gone to Albuquerque with his wife, accepting a summer teaching position at the University of New Mexico. The same year, his wife, Kerstin Bergstrom, gave birth to their daughter Nambita (Nambé). Yunkers returned to New Mexico to teach the following summer and then moved there with his family for two years between 1950 and 1952. In 1950 Yunkers was full of enthusiasm for the Southwest, as he expressed to the artist and educator Raymond Jonson: "As far as I am concerned, my personal 'salvation' lies in and through the South-West—with all its shortcomings and lovable idiosyncrasies. It's birthplace and burial ground to me."[5] Curator Malin Wilson described the local scene and quoted Yunkers:

> Although local news coverage from the early '50s in Albuquerque was predictably boosterish, a genuine and substantial art scene was undeniable. Yunkers boasted: "The climate and atmosphere in New Mexico are the most provocative in the United States. Here in New Mexico is a modern renaissance of art which is rapidly making this state the most vital cultural center of the entire country."[6]

Yunkers's statements exaggerate the importance of New Mexico, but they reflect the enthusiasm he genuinely felt about the Southwest.

Spread from *Prints in the Desert*
with *Succubae*, 1950, color woodcut,
15½ × 8 inches (image);
17¼ × 27⅝ inches (spread).
Estate of Adja Yunkers.

Yunkers built an adobe home in Corrales, on the outskirts of Albuquerque with a view of the Sandia Mountains. He joined a local artists community and started making plans for new art projects. Dore Ashton, who had studied with Yunkers at the New School for Social Research in New York in 1948 and visited Albuquerque at his invitation in the early 1950s, remembered Albuquerque: "I saw young artists who were far from provincial; who were cognizant of the currents in the metropolis from which I hailed; and who were eager to demonstrate that sophisticated art, generated by an unusual environment, was possible."[7]

In 1949 Yunkers undertook an ambitious plan to organize a private art academy, named the Rio Grande Workshop. With his students at the University of New Mexico, he published a hand-assembled portfolio titled *Prints in the Desert*, the profits from which he intended to use to help fund his workshop.[8] *Prints in the Desert* included prints by Yunkers, Jack Garver, Frederick O'Hara, and Robert Walters; a photograph by Al W. Jarrett; poetry and essays by Kenneth Lash, Ramon Sender, Edwin Honig, Vincent Garrofolo, and Elmer Gorman; and several original paintings by children (different in each folio). For the cover, Yunkers used the image of a Southwestern pictograph. Yunkers included in the portfolio his color woodcut *Succubae*, in which the demon that was believed to assume a female form to have sexual intercourse with men in their sleep is represented as a seductive dark and ghostly man-woman "melt together" (Yunkers's expression). The portfolio was printed in an edition of 220 and priced at fifteen dollars. Despite advance publicity and a rather modest price, the folio failed to attract sufficient subscribers. In 1952 Yunkers engaged in a legal battle with the Rio Grande Workshop's major sponsors, and his plans for the art academy collapsed before it opened.

Despite the failure of launching the Rio Grande Workshop, Yunkers, a European with New York contacts, made his mark in Albuquerque. Ashton credited Yunkers with helping to endow the local scene with internationalism. She stated: "This was in contrast to New York which at the time was very busy claiming its autonomy from Europe, going to sometimes foolish and nationalistic lengths. In Albuquerque, the doors were open, as is obvious in 'Prints in the Desert' with its contributors numbering many Europeans and Latin Americans as well as young local Albuquerque artists."[9]

AGAIN

Woman, part flesh part salt,
Under the immense blue
Sun-blaring cause, turning

Toward the fire-fastened city,
Her husband's warning gurgle
Just dying on the swollen air,

And she, drab wife,
Bundled in a prophecy,
That moment, see her frozen,

Burning, turning taller
Than all her godstruck kin
Breathless for the blessed ark,

The curse of all her kind
Wishing backward to
The lavish lurid safeties

From puffing on those plaint,
Those horrid distances
Of cold command.

Edwin Honig.

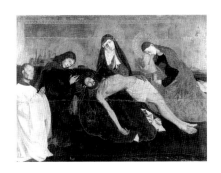

Anonymous artist (attributed to Enguerrand Charonton), *Pietà d'Avignon*, ca. 1455, tempera on wood, 64 × 86 inches. Musée du Louvre, Paris.

In New Mexico Yunkers focused on further experimentations with printmaking techniques. For the summer 1950 issue of the *New Mexico Quarterly,* Yunkers produced nine black-and-white woodcuts under the title *Swedish Songs and Ballads,* including a self-portrait based on the undated pencil drawing that recalls Kirchner's *Portrait of Jean (Hans) Arp* (see p. 28). A long article by John Palmer Leeper accompanied the prints.[10] Yunkers also began to work on several large multiblock woodcuts, including *Pietà d'Avignon,* 1951, and *The Gathering of the Clans,* 1953 (Museum of Modern Art, New York), which exemplify two different directions he took in looking for inspiration for his art: the return to the old masters and the exploration of ancient (Norse) myths and archaic imagery. Later Yunkers noted in a scrapbook, next to a reproduction of the famous medieval work glued to the page, that he had discovered the original *Pietà d'Avignon* while living in Paris in the late 1920s. He wrote: "It hung in a dark corner in one of the many huge rooms of the [Louvre] museum and it was pure chance that I found it. It made an enormous impression on me."[11]

In 1952 Yunkers made five prints for the Rio Grande Graphics project (unrelated to the Rio Grande Workshop): *Miss Ever-Ready, Head of a Traveler, Las Lolitas, Three Personages,* and *City Lights* (all National Gallery of Art, Washington, D.C.).[12] Here he demonstrated the full scale of his possibilities in working in different styles, from the figurative *Head of a Traveler* to the nearly abstract *City Lights.* While in New Mexico, he also produced a series of exquisite monotypes, such as *La Messa Negra* and *The Mojave Desert,* both 1949 (National Gallery of Art, Washington, D.C.), in which he elevated the role of chance and spontaneity to a new level by exploring rich possibilities provided by collage materials such as paper, tissue, strings, and burlap.

The natural beauty of the Southwest had its dangers, as Yunkers discovered when his Corrales studio flooded twice, destroying many of his prints. Further, Yunkers's relationship with his wife rapidly deteriorated, and in 1952 he and Bergstrom were divorced. Yunkers summarized his disappointment with the place that had witnessed his new misfortunes with a typical conclusiveness: "The Southwest is the manliest and the most merciless country I have ever encountered."[13] In a quick succession of events he returned to New York, married Ashton, who became his fifth and last wife (the couple moved to a walk-up apartment on East Thirty-fourth Street in Manhattan), and was granted American citizenship in December 1953.

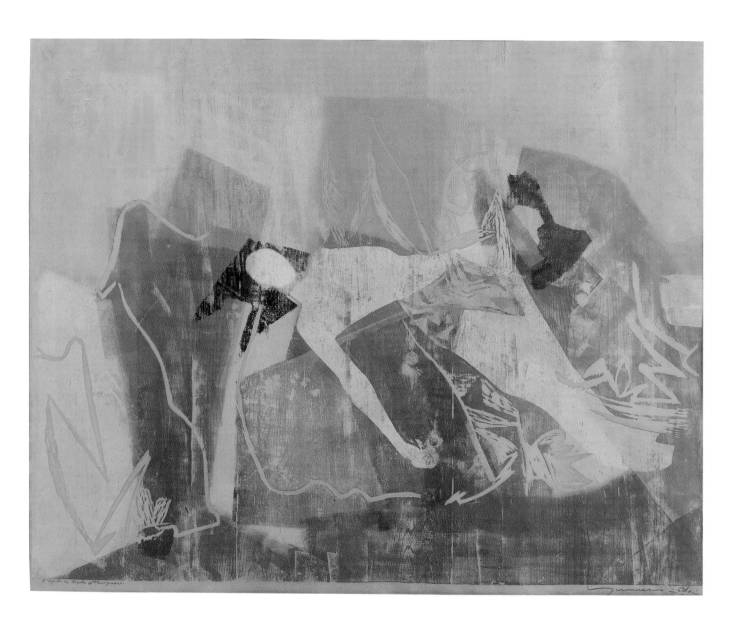

Pietà d'Avignon, 1951,
color woodcut, 39½ × 48½ inches.
Estate of Adja Yunkers.

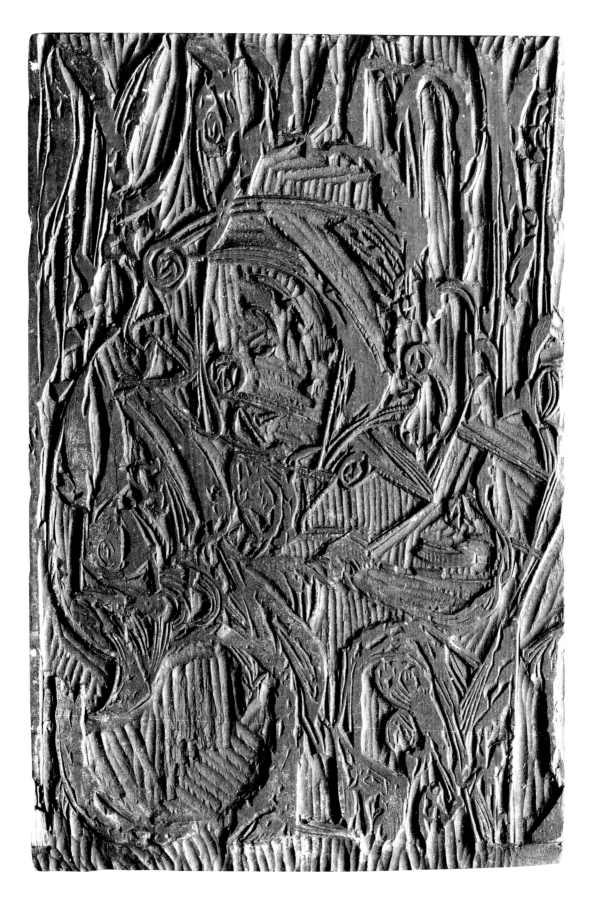

Head of a Traveler, 1952, wood block
for the woodcut, 13½ × 9¼ inches.
Estate of Adja Yunkers.

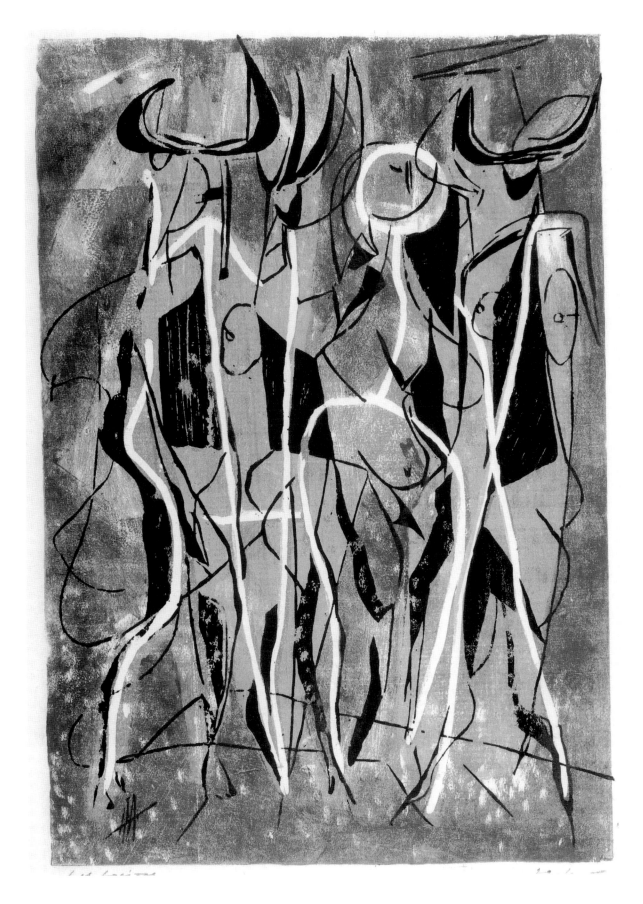

Las Lolitas, 1952, color woodcut
on Oriental paper, 20½ × 15 inches.
National Gallery of Art, Washington
D.C., Rosenwald Collection.

Back in New York, Yunkers began to work on a multipanel woodcut titled *Polyptych*, 1953. The ambitious project consisted of five large woodcuts made of four to eight blocks each and twenty-five to fifty-six colors. But in the fourth of what was now becoming a series of disasters that had affected Yunkers's work and life, the ceiling of his studio caved in in April 1953, destroying much of the edition.[14] Once more, with characteristic determination, Yunkers picked up the pieces and redid the lost work in time for the exhibition's opening at the Grace Borgenicht Gallery in New York in May 1953.

In his application for the 1954 renewal of his Guggenheim Fellowship, Yunkers attached a detailed description of his work, which had previously served as the press release for the May 1953 exhibition. It described *Polyptych* (without alluding to the recent disaster):

> Five panels about 14 feet long and 44 inches high. . . .
> All five panels are related in the following scheme:
> > End panels: Universal observations
> > Middle panels: Individual aspects
> > Center panel: synthesis of all four
> Throughout the work two humans, man and woman, are identified through and with each other. The artist's thesis is that the unit of man-woman is greater than the sum of disasters that overtake them. All side panels are aspects or intermediary states while the great center panel is a summary.[15]

Printed by hand, the individual panels were titled: *The Power of Circumstance* (far left panel), *Personal Epiphany* (left middle panel), *Magnificat* (central panel), *The Chaos of Unreason* (right middle panel), and *The Graveyard of the Cathedrals* (far right panel).

The press release provided a detailed explanation for each of the five woodcuts, offering an important insight into how Yunkers approached formal aspects in relation to the subjects of his works. *The Power of Circumstance* formally recalled *The Gathering of the Clans* and *Succubae*, depicting "man-woman flanked by iron men, armored figures with spiked tongues, one shouting shrill atavisms." The figures are frontal and close to the picture plane to convey "terrifying immediacy." *Personal Epiphany* repeats the same male-female double figure, this time endowing it with personal significance: the man is the artist, the woman, his pregnant wife. The artist is portrayed as "a medium of a higher order," for which "the creative act becomes the individual salvation." The central piece, *Magnificat*, is a statement about the oneness of man and woman—"as long as they are a unit, nothing can conquer them." The description emphasizes a range of colors that "picks up tonalities from the other panels, producing a crescendo which synthesizes the whole." *The Chaos of Unreason* contains a plethora "of unsorted images and sensations,"

including discarded mannequins and fleeing human figures. Finally, in *The Graveyard of the Cathedrals,*

> a great cathedral, teetering on an axis diagonal to the picture plane, symbolizes the loss of beliefs in the twentieth century. Figures are pinioned to the disintegrating summit. Spires perforate the sky in which lurk three ominous moons. There are no portals in this skeletal cathedral. Lunar illumination comes from behind suggesting impending disaster. Red touches on this sober print are like congealed blood. A flame on the lower left bottom reveals the man and the woman, petrified. In the lower right, discreetly sequestered in rubble, the man and woman make love.[16]

Polyptych is an impressive graphic work with a philosophical credo that combines an extensive knowledge of art and history with personal experiences and obsessions. A reviewer in *Art and Architecture* noted that the work was animated by lyrical feelings about women and "tempered by an existentialist sorrow."[17] Adelyn D. Breeskin of the Baltimore Museum of Art described *Polyptych* as a unique "commentary on the world of today" and "a landmark in the history of the graphic arts."[18]

When Yunkers applied for his second Guggenheim Fellowship, he and Ashton had already made arrangements to take a trip to Europe. (He asked to have the second payment of his fellowship sent to Rome.) Soon after arriving in Rome, Yunkers wrote to Henry A. Moe at the Guggenheim Foundation:

> Dear Mr. Moe:
> I am happy to tell you that my wife and I are now settled in Rome in an apartment we were lucky to find and that I can now begin to work seriously after all these months of studies and experiences during our travels in Europe. I am also happy to be able to tell you that the "Polyptych," the basis for the renewal of my fellowship—has been everywhere in Europe a great success and as a result

Polyptych: The Power of Circumstance, Personal Epiphany, Magnificat, The Chaos of Unreason, and *The Graveyard of the Cathedrals,* 1953, five color woodcuts; far left panel: 37¾ × 22¾ inches; middle left and middle right panels: 44 × 20 inches; middle panel: 48 × 44 inches; far right panel: 37 × 23¾ inches. Private collection, Cleveland.

Force of Circumstance

Warrior on Chariot, 1955,
oil on cardboard, 7 × 9¾ inches.
Whereabouts unknown;
photograph courtesy of the
Estate of Adja Yunkers.

I will have one-man shows in London, Berlin, Paris, Basel and Rome during the coming year.[19]

The couple lived on Via Dei Gracchi in the center of Rome, with a view of the dome of the Vatican Cathedral, so close to Vatican City that they joked that they could hear the hiccups of the dying pope. In photographs taken in Rome during this time, Yunkers is happy and relaxed, wearing casual clothes.

Yunkers's folder with black-and-white photographs of his works from Italy contains a picture of his *Warrior on Chariot,* inscribed "Rome, 1955" (whereabouts unknown). This small, experimental oil on paper has a centrifugal, open composition. Closer examination of the painting connects it to its title: the warrior and his horse-ridden chariot are seen from above, with the splashes and stains standing for the ciphers of motion and delineating the direction of the movement toward the upper middle. The image is heavily textured, which adds to its expressive quality. At the same time, it has a ghostlike quality that makes it look like a shadow of the real warrior on the chariot, recalling Plato's famous cave analogy: we witness activities of others as shadows intermingled with our shadows, and as our eyes allow us to believe that these flickering images are real, we experience the reality through secondhand information and sensations.

Among the people with whom Yunkers renewed contacts in Europe was the art historian Will Grohmann. On the occasion of a 1955 show at Grace Borgenicht Gallery, Grohmann wrote:

> In Rome, Yunkers found the "way to the Mother." He turned his back on narration and discovered sources from which no narratives arise, only images, eidola. Perhaps it was no coincidence that this happened in Ostia, Rome's old 7th century harbor. From these excavations an archetypal rather than an historic spirit emerges—what Yunkers saw he transferred to woodcuts and monotypes which are just as original as paintings, only more direct in their impact and therefore more objective.[20]

Grohmann refers here to *Ostia Antica,* 1955, a series of woodcuts and monotypes designated in numbers from I to XII and executed in earthy colors of subtle tonality that allude to the ancient nature of the historic place in Italy. The prints are basically abstract, but they bring to mind fragments of the walls of Ostia Antica, with their cardinal-red color and dwarfed, ruinous presence. The palimpsest character of Yunkers's prints, with their emphasis on the irregular, incomplete, incoherent, and accidental (in terms of both inscriptions and erasures), adds drama to the fixed images. In the monotypes of this series, by working with a medium that gave greater freedom of direct expression than woodcuts, Yunkers went even further toward gesture and abstraction.

In 1956, when the Print Club of Philadelphia asked fourteen distinguished museum curators to choose the best five prints from the previous five years, five of them selected Yunkers's works, either *Polyptych* or one of the *Ostia Antica* prints.[21] The woodcut *Ostia Antica VI*, 1955 (Library of Congress, Washington, D.C.), was prominently presented in a juried exhibition at the Brooklyn Museum called *Ten Years of American Prints, 1947–1956* and featured in its catalogue. Despite an overwhelmingly positive response to the *Ostia Antica* prints, they were, however, Yunkers's last woodcuts before he would return to the medium in the mid-1960s. He told Paul Cummings:

> The important thing was an experience I had in Ostia Antica, which is the original, the first harbor the Romans built which was built by seamen and merchants. They had everything there, the senate, the theaters, the entire city, and it lasted fifty years or something like that. Suddenly one morning they awakened and the sea had receded a hundred miles, just receded. And it was a ghost town, they abandoned it. Now still today there are inlaid symbols the size of this carpet where they had their stalls, in the fisherman's there were little fishes, in the shoemaker's there were shoes. Beautiful things that you walk on, and it's absolutely empty.... Ostia Antica was a significant experience: I made my last woodcuts in Rome... I made thirty large woodcuts... I haven't made any woodcuts since, I just abandoned it.[22]

Yunkers's abandonment of the woodcut medium before his return to America was a brave act, considering that he was highly respected in the United States for his mastery of that medium. But it was perhaps a necessary step toward the next reinvention of himself as an artist.

Chapter 4

European Artist in New York

You never lose your way, and you are always lost.

—Jean-Paul Sartre[1]

Yunkers and Ashton returned to New York from Italy in the fall of 1955. They stayed for a while in the Chelsea Hotel, before moving to a studio on East Twenty-eighth Street. Around this time Yunkers began to work on a series of abstract drawings and paintings. For some time reviewers had been stressing the painterly quality of Yunkers's prints, which could not have escaped the artist's attention. But the decisive step toward painting was probably made because of the importance of Abstract Expressionism and its emphasis on painting as a medium for ultimate, free creation. In his earlier small oil sketches, Yunkers experimented with spontaneous gesture by splashing paint on paper and using sweeping brushstrokes. He also produced a number of gouache *decalcomanias* on paper.[2] Such works brought Yunkers stylistically closer to the Abstract Expressionists, many of whom he knew personally. By the fall of 1955, when Ashton began to write for the *New York Times*, their contacts with the New York artistic community were becoming more frequent and closer.

Yunkers's relationship with New York Abstract Expressionists was complicated. He did not grow up with them and attend the same schools, and he was older than most of them. Therefore Yunkers had to learn how to find his way around their world. When asked about which artists he had met upon arriving in New York, he replied that he met just a few faculty members of the New School, because he spoke little English and was relatively shy. He added, "And then another thing was what is quite typical for any foreigner actually who comes over here, the confrontation with the different mechanism of thinking." He then described the European way of communicating as full of "on the one hand, on the other hand, maybe, and perhaps," as opposed to the American "I like you, You don't like me—Bang! hits you on the head, you know."[3]

Yunkers quickly adopted some of the artistic vocabulary as well as jargon used by the Abstract Expressionists, but when he was asked whether he was involved with the Club, an informal group of New York artists who got together at 35 East Eighth Street, he answered:

Oh, yes, I used to visit them. But, you see, look, to me that was like playing in sandboxes. I just gave it up. It was a bore, an endless bore. I understand perfectly well why these things had to happen. It's good that it happened, that it was there. But not for me. I didn't need it, you see, because I had my identity. In the 1940s and 1950s they were looking for identity.... Gradually I got to know them all. The best of them became my friends, and good friends. And that's the only communication I have here, these few people whom I can talk to. We do not even have to talk because we are on the same wavelength and there's no need for talking.[4]

Odilon Redon, *The Window*, ca. 1907, pastel, 25 × 19 inches. Kunsthaus, Zurich.

Yunkers reproached New York artists (with the exception of Robert Motherwell) for refusing to talk politics and only being able to discuss "their mistresses, their wives, their kids, their taxes, their villas, all that nonsense. Never about art." He concluded: "The Club and all that was a sort of a sly finding out about a possible combination between a good life, materialism, and aesthetics. You know, they never go together."[5]

Although he was undoubtedly influenced by his friends in the Club, Yunkers was intent on exploring his own creative boundaries. An accident helped him arrive at a new stage in his career. (Discovering by accident new ways of making art was, of course, a part of the Abstract Expressionist ethos.) After having produced a number of experimental charcoal drawings, he began to work with pastels:

> One day the Borgenicht Gallery asked me if they could have a small work. I just looked around and I saw a few pastel sticks lying around that I used to sketch with but never made a pastel. I thought, well, she wants a little thing so I'm going to make a little thing. So I made a little thing. And it was fascinating what I could do with it. I sent it to her gallery. It lasted one hour; it was gone. So then I developed a technique which nobody, nobody [knew]—Degas in that sense is a Sunday painter in comparison—not only in size but especially in technique. You know, he would draw them using strokes. Well, I would use three or four sticks in the palm of my hand and use them like oil color technique.[6]

Experimenting with pastels, Yunkers was following in the footsteps of such artists as Edgar Degas and Odilon Redon. Redon's works, such as *The Window*, ca. 1907, set new standards for the virtuosic handling of the medium. Willem de Kooning, whose works (including his pastels) provided a crucial link between European painterly tradition and Abstract Expressionism, also inspired Yunkers.

Yunkers's earliest large pastels, dated 1956–57, titled *Composition* with consecutive numbers, were mixed with tempera and executed on canvas.[7] They were included in his March–April 1957 solo exhibition at the Rose Fried Gallery in New York. The *Compositions* consist of two areas of contrasting colors placed side by side on a lighter background, producing an effect of reverie mixed with geometry (as in

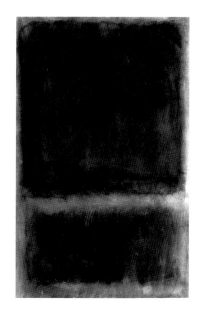

Mark Rothko, *Untitled*, 1968,
acrylic on paper mounted
on panel, 40⅝ × 26⅜ inches.
National Gallery of Art, Washington,
D.C., Gift of the Mark Rothko
Foundation.

Yunkers with Mark Rothko, ca. 1960,
photograph from a scrapbook.
Museum of Modern Art, New York.

Dürer's *Melancolia*, 1514). These pastels recall Mark Rothko's works from the period, which should not be surprising. A founder of the Club, Rothko showed his work almost yearly at Betty Parsons Gallery in the late 1940s and early 1950s and then at Sidney Janis Gallery in 1955 and 1957. (In 1957 Yunkers joined the influential André Emmerich Gallery.) Ashton began to write on Rothko around 1958, publishing articles and reviews in *Art and Architecture*, the *New York Times*, and *Cimaise*. Yunkers had known Rothko since the early 1950s, and Rothko was a frequent visitor at the Ashton-Yunkers home until his death in 1970.

Like Rothko, Yunkers approached color as a vehicle for achieving what critic Thomas B. Hess called "a balance of equalities disguised by scale," using color for creating a mood and producing symmetry.[8] But Yunkers's paintings appear more material, more pregnant with the physical presence of paints than are Rothko's. They are also more referential, as if Yunkers was too connected to life to succumb to total abstraction. Some of his *Compositions* may, in fact, be read as angry attempts to turn Rothko's paintings upside down—or rather sideways, to a horizontal position. In other works, Yunkers returns to the vertical arrangement of forms, slashing canvas with lines and putting them out of balance with rectangles that ooze with paint. That direction was fully explored in *Composition in Black and Ocher*, dated March 11, 1957, an exquisite work executed with a total command of the medium.[9]

Yunkers was fully aware of Rothko's impact on his art. He respected Rothko highly and also felt competitive toward him. Late in life, when Yunkers arranged his scrapbooks, he glued a photograph of himself with Rothko, taken in the late 1950s or early 1960s, to one of the pages and wrote next to it:

> He [Rothko] always impressed me as being a defrocked rabbi. The photo was taken at one of my openings of my big pastels at the Emmerich Gallery and I am proud to be able to say that the best artists of New York were present. At a big party Dore and I were giving—Rothko was present as well as Bob Motherwell, Philip Guston and others. Rothko was taciturn, dark and very troubled and so—passing him in serving drinks I would exchange a few words with him and the following is just one of many indications of his troubled soul. He was standing with his back to a small painting he had given us as a present.
>
> A: Look Mark, why don't you just give up painting for a while and make some prints to get distance to yourself?
> M.R.: Turning toward his painting (which I had to restore being full of cracks) asked me: "Could I do a print like this?"
> A: Of course Mark, ten minutes of technical instruction and off you go—
>
> Later passing by him again:
> A: By the way, Mark—to my mind, an artist is a round person, not fat (jokingly)

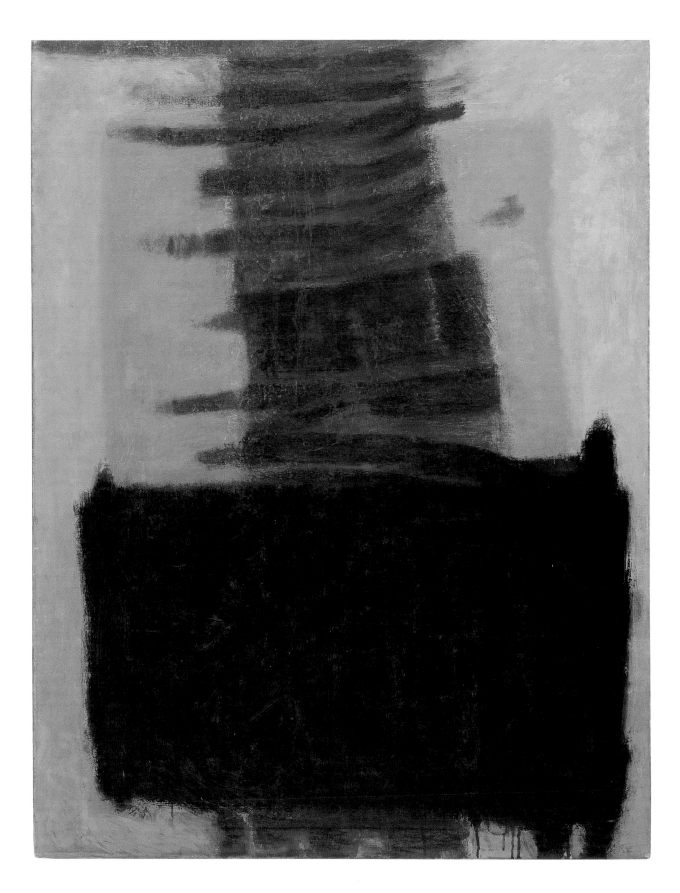

Composition in Black and Ocher
(3–11–57), 1957, oil on canvas,
48 × 37 inches.
Solomon R. Guggenheim Museum,
New York.

who—creates art with whatever he touches! Look at European artists—no medium is strange to them—Matisse, Braque, Picasso, etc., etc.

Later again passing Mark stops me and without looking at me, in an undertone of sadness says: "Adja, I don't think I ever was a round man."[10]

Yunkers continues his recollections by describing a visit to Rothko's studio to see new paintings. "I was shocked at the deadness of the paintings," he writes, "and the gruesome loneliness they revealed in their ugliness. . . . [a] few days later he had committed suicide." Following Rothko's death, Yunkers painted a number of works in memoriam, including *Elegy for a Dead Painter, Mark Rothko*, 1970; *Mark Rothko, In Memoriam*, 1971 (both the Estate of Adja Yunkers); and *Presaging the Night (Homage to Rothko)*, 1973.

In the 1950s Yunkers was busy working and exhibiting in New York, but he and Ashton made a point to travel abroad each year during their summer breaks. In the summer of 1957 they took a trip to Spain, visiting Madrid, Seville, and Barcelona, before traveling by bus to Portugal. Ashton recalled their visit to Barcelona:

I was not prepared for the overwhelming impression of bleakness during my first days in Spain. The place was dusty. There were bullet-pocked walls (all too explicit for my youthful imagination). On the Ramblas I saw mutilated men and pairs of the dreaded Guardia Civil everywhere. The few artists and connoisseurs I met talked bitterly of censorship, isolation, and the impossibility of seeing movies that had not been gutted of meaning by the censors. From Barcelona I went directly to Madrid, where, if anything, things seemed even more depressing.[11]

During their trip, Yunkers and Ashton met with the painters Antonio Saura and Antoni Tàpies, asking Tàpies to show them Tarrasa, a Catalan city known for its ancient art and architecture: a mixture of Roman, Romanesque, and early Gothic. To their surprise, Tàpies did not know much about the place, which was located only about forty kilometers from Barcelona.[12] They visited Tarrasa with Tàpies, and the trip resulted in a series of pastels named after the town that were consecutively numbered from I to XIII. Yunkers first made a number of preliminary studies in watercolor and pastel, such as *Tarrasa Pequeño*, 1957 (private collection, New York). Like many of Yunkers's pastels, *Tarrasa Pequeño*, a thinly washed and dark tonal abstraction (it is of the size of a postcard: 4½ by 3 inches) conveys a baroque richness of form that is rather foreign to the Romanesque austerity of churches in Tarrasa. But Yunkers did not attempt to capture the formal similarity between the Spanish town and its contemporary visualization; instead he conveys a sense of bewilderment at a view of a spectacular place. The *Tarrassa* pastels of 1958 are like improvisations on recollections that slowly become reality; the artist fixes the image and at the same time accepts the changing aspect of memory.

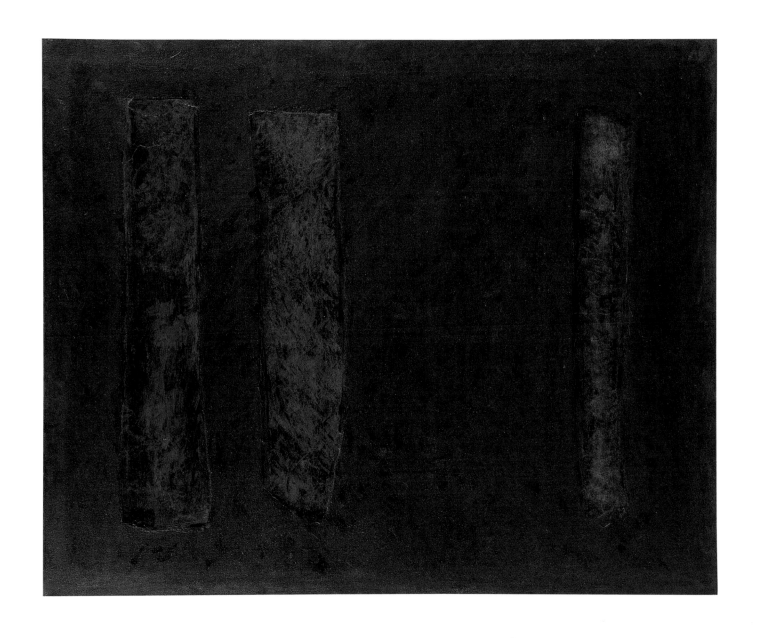

Fête Galante, 1960, gouache
on cardboard, 26¼ × 20 inches.
Cleveland Museum of Art,
Contemporary Collection.

Between *Tarrasa I* and *Tarrasa XIII* there is no linear connection; instead, in engaging his memory in action, Yunkers spans visual history between the Roman and present times. Uniting these works is a sense of inner solidity that may have had its source in religious experience or a tradition of art based on monastic simplicity and beauty.

The trip to Spain resulted in other large works with figurative associations (inspired by Goya's black paintings), such as *Embroidered Halo*, 1958, and the *Bewitcher's Sabbath* series, 1958 (various collections), which one critic described as "a cauldron of color."[13] Yunkers's authority in handling the pastel medium and the unprecedented scale of the new works gained him vast admiration from critics and collectors in New York.[14]

In 1958 Yunkers also began to execute a series of small gouaches that range between preparatory sketches and finished works. Reproductions of a few of them were included in the fall 1959 issue of *It Is* magazine, and one, an untitled gouache dated August 4, 1959 (II), appeared on the same page as Philip Guston's work, unavoidably provoking a comparison between the two artists. The closeness of Yunkers's style to that of Guston in the late 1950s did not escape the attention of the critic and curator Edward B. Henning, who in his book *Fifty Years of Modern Art, 1916–1966* placed Guston's *Sleeper I*, 1958, next to Yunkers's *Sestina II* of the same year and wrote:

> As *Sestina II* demonstrates, in this artist's hands the medium [pastel] is painterly rather than a method of drawing with color. In a manner close to that of Guston's, the vigorous, rhythmical strokes of color interweave and coalesce to suggest images that seem to emerge from shadow and then recede as one tries to perceive their definition.[15]

During the 1950s, when the two artists worked in similar styles, Yunkers retitled his *Spanish Landscape*, dated October 18, 1956, *Homage to Philip Guston* (private collection) and included it in his 1957 show at Rose Fried Gallery. Yunkers's *Fête Galante*, 1960, translates Antoine Watteau's *Pilgrimage to Cythera*, 1717, set in the island of love, into an abstract play of bright, luscious colors applied thickly with swift brushstrokes to cardboard. The work is, however, closer to Guston's *Cythera*, 1957, although Guston followed Watteau's design and composition more closely, concentrating on the couple in the middle of the painting. Yunkers's *Fête Galante* demonstrates how he drew from the tradition of European painting and simultaneously filtered it through the optics of contemporary art.

Philip Guston, *Cythera*, 1957, oil on canvas, 72⅛ × 63¾ inches. Donald Blinken Collection.

Antoine Watteau, *Pilgrimage to Cythera*, 1717, oil on canvas, 50¾ × 74¾ inches. Musée du Louvre, Paris.

Embroidered Halo, 1958,
oil on canvas, 64 × 48 inches.
Hirshhorn Museum and Sculpture
Garden, Smithsonian Institution,
Washington, D.C., Gift of
Joseph H. Hirshhorn.

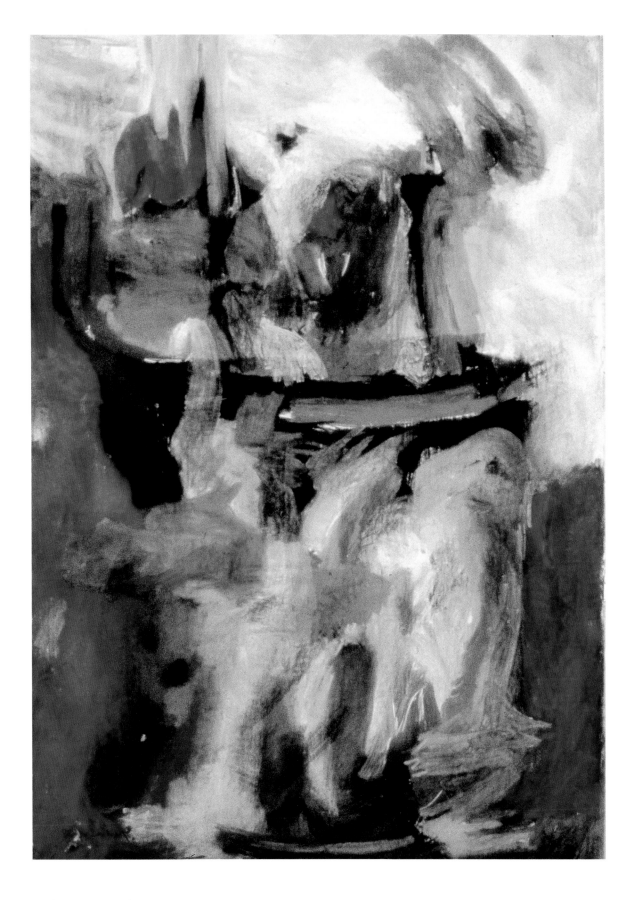

Sestina II, 1958, pastel on paper,
66 × 48 inches.
Cleveland Museum of Art,
Agnes Gund Collection.

PHILIP GUSTON WAS AN EXTRAORDI
NARY PAINTERLY ~~PAINTERLY~~ PAINTER
BUT HE INSISTED WANTING TO
BE THE "PAINTER #1" IN AMERICA WHICH
INSISTENCE MADE IT IMPOSSIBLE TO ACHIEVE
IT. AMBITION KILLED HIM.

Yunkers with Philip Guston,
date unknown, photograph
from a scrapbook.
Museum of Modern Art, New York.

Although the two artists knew each other well, Yunkers criticized Guston toward the end of his life. In one of his scrapbooks he wrote next to an undated photograph of himself with Guston: "Philip Guston was an extraordinary painterly painter but he insisted [on] wanting to be the 'Painter #1' in America, which insistence made it impossible to achieve it. Ambition killed him." A short letter from Guston dated March 20, 1980, accompanies the text.[16]

By the late 1950s Yunkers had returned to explicit figuration. He created *The Jewish Bride* in 1959, originally titled *Confrontation*, in which he used the motif of a couple merging into one figure. Yunkers mentioned Rembrandt's *Jewish Bride* in a statement provided for *It Is:*

> I like to think of Rembrandt's "Jewish Bride" in which the bridegroom reaches out for the heart of his beloved. His hand barely touches her breast—but what about the time and space between that hand and that heart? There is the true drama and I hate to think of "explanations" that will not in any case be able to explain the innertness [*sic*].[17]

Rembrandt played an important role in Yunkers's pantheon of great masters. Yunkers once clipped a historic photograph of Rembrandt's *Night Watch,* 1642, after it had been slashed with a knife by an unemployed ship's cook in 1911; he kept the clipping, glued to a piece of cardboard, throughout the rest of his life. Interestingly enough, the vertical slashes on Rembrandt's masterpiece are echoed in the rhythmic verticals in a number of Yunkers's *Compositions,* opening up the possibility of equating Yunkers's abstractions to the violent act of painting in general and to self-destruction. In 1976 Yunkers painted *The Wounds of Rembrandt* (acrylic and collage, Estate of Adja Yunkers), a large work that looks like a pictogram made of rope and shaped into a totemic figure. In his personal files he kept a postcard of a late Rembrandt self-portrait, sent to him by Ashton from London in the late 1970s.[18]

The masterly use of pastel as a translucent medium is apparent in *Discourse,* 1959 (private collection, Cleveland), another work that depicts two figures—this time clearly separated, as if engaged in conversation. The two protagonists, painted in vibrant reds and blues, look like characters from medieval times or an undefined folkloric culture. There is something almost dancelike in the way the figures face one another, as if the conversation is only momentary. The title seems to be a misnomer, for a discourse requires the power to think consecutively and logically, whereas in Yunkers's work the medium, colors, and formal composition allude to art as the expression of the spontaneous, intimate, and sensual.

In the summer of 1959 Yunkers and Ashton traveled to Martinique and Guadeloupe in the West Indies, and when they returned Yunkers created a series of pastels and gouaches with *Guadeloupe* and/or *Gosier* (the main town in Guadeloupe) in their titles. The colors in *Guadeloupe*, 1959–60, are less vibrant than those of *The Jewish Bride* or *Discourse*, and the delicacy of the image is enhanced by the artist's use of delicate grays, browns, and pinks. This abstract image produces figurative associations, confirming Jackson Pollock's observation: "When you're painting out of your unconscious, figures are bound to emerge."[19]

Yunkers (far right) with Martha Jackson (third from right) aboard the *Queen Mary*, 1960. Photograph courtesy of Dore Ashton.

Ashton said that she traveled to Guadeloupe with a "mission"—to visit the birthplace of the French poet Saint-John Perse (born on a small coral island off the main island of Guadeloupe) and to write an article about him. Saint-John Perse would receive the Nobel Prize in 1960. Yunkers surely read the poet, and his poetry probably stimulated his imagination. Looking at his *Guadeloupe*, one can almost hear the poet's synergistic voice:

Yunkers in Venice, 1960. Photograph courtesy of Marina Yunkers.

> Palms...!
> In those days they bathed you in water-of-green-leaves; and the water was of green sun too; and your mother's maids, tall glossy girls, moved their warm legs near you who trembled.... [20]

In 1960 Yunkers concentrated on small works—gouaches, pastels, and ink drawings. He produced them in large numbers, almost in a stream-of-consciousness fashion. Most of the works from 1960 anticipated the *Skies of Venice* prints (National Gallery of Art, Washington, D.C., and Estate of Adja Yunkers) and his late black-and-white pastels. *Hydra II*, 1960 (Estate of Adja Yunkers), looks like an ink-blot landscape, while another small ink drawing, *Untitled*, 1960 (Estate of Adja Yunkers), returns to the style of his experimental monotypes from New Mexico and the *decalcomanias*. It is quite clear that Yunkers was embracing a reduced palette and abstract forms in these works.

Yunkers and Ashton took a trip to Italy in 1960 and visited the Venice Biennale, which awarded the top prize to their friend, the Italian artist Emilio Vedova. They left New York aboard the R.M.S. *Queen Mary*, traveling with, among others, the gallery owner Martha Jackson and the French critic Michel Tapie. By then they were members of the exclusive international art community that included artists, critics, gallery owners, and collectors.

The Jewish Bride, 1959,
pastel, 69 × 47 inches.
Private collection, Cleveland.

Guadeloupe, 1959–60, pastel,
69 × 47 inches.
Private collection, Cleveland.

After Yunkers returned from Italy, June Wayne invited him to work at the Tamarind Lithography Workshop in the fall of 1960. A radical artist and print-maker, Wayne had been trained in lithography in Europe and was determined to revitalize lithography in the United States. Although this printing technique was not unfamiliar to American artists, as Clinton Adams observed in his *American Lithographers, 1900–1960*, it was rejected by Abstract Expressionists in part for its "nationalist" character; it was associated with social realism and considered devoid of the immediacy achieved through a direct involvement with art making. Adams quoted Franz Kline: "Printmaking concerns social attitudes, you know—politics and a public . . . like the Mexicans in the 1930s; printing, multiplying, educating. I can't think about it. I am involved with the private image."[21]

In the brochure "Tamarind Impressions: Lithographs from the Tamarind Workshop," Wayne stated:

> The art of lithography, barely a century and a half old, by 1960 had gone into a serious decline in the United States, sharing the crisis of all craft-based art forms in this machine age. Although many American artists would have contin-ued working in this remarkable medium, relentless social changes had reduced the number of master-printers almost to extinction. Only a few artists with the equipment and temperament to become their own printers managed to continue in lithography. Indeed, there seemed a real possibility the art would vanish entirely unless a rescue operation took place. This is why Tamarind Lithography Workshop, functioning under a grant from the Program in Humanities and The Arts of the Ford Foundation, came into being.[22]

The workshop provided a laboratory in which artists and master printers could work together. Yunkers's previous experience with lithography was quite limited, although he had produced a number of small lithographs in the late 1950s, includ-ing *Git le Coeur*, 1958, and *Walking along the Cliffs*, 1959 (both Estate of Adja Yunkers), which in their search for spontaneous expression paralleled his small gouaches and pastels. Tamarind offered him the opportunity to work with highly skilled professional master printers and to engage in a larger project. The suite of five lithographs on Nacre paper called *Salt* (National Gallery of Art, Washington, D.C.) demonstrates both Yunkers's talent with handling the medium and his enthusiasm for it. He recalled:

> I loved it. I had three master-printers at my beck and call. I made many, many experiments there which had never been done in lithography. . . . There was this one printer, a Czechoslovakian—Horak is his name—who had started doing this as a boy; he had grown up with it and he was really fantastic! We would start working at six in the morning and work until twelve and one o'clock at night. We did this for six weeks.[23]

Yunkers further confirmed his enthusiasm in a letter to Una Johnson: "I cannot tell you how wonderful it was to work there and I never would have been able to produce a volume of work without the shop, its printers, and the conducive atmosphere."[24]

Yunkers produced two print portfolios at Tamarind, *Salt* and *The Skies of Venice*. In the *Salt* series, he used translucent washes of color that vary from print to print, from grays to emerald greens to browns to pale ochers. In one print, the artist placed a red dot, repeating a refined mysterious mark that appears in many of his works—akin to Klee's little arrow.[25] Yunkers clearly enjoyed the beauty of Nacre paper; he left its edges irregular, further emphasizing the delicacy of his works.

Yunkers's choice of a title for the *Salt* series is explained by a press release from the Tamarind Lithography Workshop dated January 26, 1961: "During the first half of his Tamarind Fellowship, Mr. Yunkers created five works (two in black and white—three in color) for a forthcoming de luxe book undertaken in collaboration with Mr. Stanley Kunitz, distinguished American poet. Mr. Kunitz' poem, written for this occasion, is titled SALT, and will be published by André Emmerich in a limited edition of 125 volumes."[26]

Yunkers's maturity in handling lithography found its full realization in the *Skies of Venice* series, which consisted of nine prints consecutively numbered from I to IX. *The Skies of Venice* are recollections of Yunkers's sojourns in the Italian city, in which he and Ashton had spent significant time looking at Venetian masters, admiring particularly Titian and Tintoretto. The spontaneity and rich chiaroscuro of Titian's works greatly appealed to Yunkers. In *The Skies of Venice*, Yunkers used similar free, quick brushstrokes and surprisingly transparent, deep, dark tones, which allowed him to create his chiaroscuro effect with absolute authority.

Ashton remembers that they stayed in an apartment with a terrace in the Giudecca, from which they had an impressive view of Venice dominated by a spectacular, heavy sky. Yunkers's images of the Venetian sky are derived as much from his apartment's view of the city as from the paintings in S. Giorgio Maggiore and the Scuola di San Rocco, two historic buildings that are separated from the famous cityscape by thick walls. Yunkers worked with just blacks, grays, and whites, rather than choosing colors that evoke Venice's outdoor splendor. His sky swirls, filling the space with emotional intensity, like the angels in Tintoretto's *Last Supper*, 1592–94, and the soul of Count Orgaz in El Greco's *Burial of Count Orgaz*, 1586, a painting that Yunkers had seen in Toledo. In *The Skies of Venice*, Yunkers experimented with formats ranging from long horizontals, as in *The Skies of Venice VI*, to the oval in *The Skies of Venice VIII*. He used a complex technique of mixing ink with tempera to achieve a rich gamut of grays, applying them to the lithographic stone with brushes. "The only difficulty," he said, "was to hold it up in the edition, the same gray, so that it wouldn't disappear, or get black."[27] Numerous proofs

The Skies of Venice I, 1960,
lithograph, 21½ × 31 inches.
Estate of Adja Yunkers.

The Skies of Venice III, 1960,
lithograph (cancellation proof),
21 × 27¼ inches.
Estate of Adja Yunkers.

Postcard from Yunkers to Robert
Motherwell, May 22, 1963.
Courtesy of the Dedalus Foundation.

crossed out by the artist clearly demonstrated that he was looking for a specific effect.

When Yunkers returned to his large pastels in 1961, he brought to them his Tamarind experience. At first he tried to apply it to sketches and in his lithograph *Walking along the Cliffs*, 1959. Then he created the large pastels *Walking along the Cliffs I* and *II*, 1961 (both private collection), with massive black vertical shapes that move horizontally toward the right side of the picture. They are executed with barlike strokes and contain concomitant areas of dark and pale purples, ochers, and pinks. These works bring to mind Motherwell's *Wall Paintings* from the early and mid-1950s, as well as his *Painting with Two Figures*, 1958, and various *Elegies to the Spanish Republic*. But where Motherwell's forms are silhouetted, those of Yunkers are more open, drawn more intuitively.

In a letter to an unidentified man named John, dated November 10, 1956, Motherwell wrote: "I believe the real artistic relatedness is 'not influence' the way historians tend to write about it, but Edmund Wilson's 'shock of recognition,' that is, seeing something you recognize and are confirmed in what you already are—though it is true also that there are Kierkegaardian 'leaps,' sprung by paradoxical faith."[28] This kind of instant "recognition" probably motivated Yunkers to cut out a photograph from a magazine and send it to Motherwell, declaring it "remarkably 'Motherwell.'"[29]

In one of the letters deposited at the Dedalus Foundation, Yunkers wrote to Motherwell in 1963, quoting Vincent van Gogh:

> "Nous ne pouvont rien aimer que par rapport à nous et nous ne fairons
> que suivre notre goût et notre passion quand nous préféront nos amis à nous
> mêmes, c'est néanmoins par cette préférence seule que l'amitié peut être vraie
> et partfaite." Vincent's "Letter" in *Art News* is not only childish but disgusting.
> As ever, Adja.[30]

Motherwell owned *Portrait of D.A.*, 1961, a bronze that Yunkers made from a plaster cast, which is one of only several sculptures that Yunkers produced in his long career. The work depicts a bust of a woman (Dore Ashton) with a long neck and a face "enclosed" in a trapezoidal shape, as if she is peeking through a keyhole. The sculpture demonstrates a sophisticated feel for texture, but it is quite conventional formally: vertical and on a pedestal. It captures, however, the graceful poise of the model and conveys a sense of admiration for female beauty.[31]

Yunkers always respected Motherwell, although their friendship deteriorated in the 1960s. Ashton confirms that Yunkers and Motherwell were friends, though never particularly close. She said:

Adja did not get along very well with American artists, and they kept him at a distance. There was obviously a certain degree of rivalry involved, but there was also something else. Adja related much better to European artists than to Americans. For example, he and Bill de Kooning understood each other well. [Yunkers and de Kooning had studios in the same building on Tenth Street in the late 1950s.] They seemed to share a common disdain of Americans.[32]

Perhaps more important, de Kooning and Yunkers were both highly suspicious of collective identity, perceived as a style, movement, or social grouping.[33] In one of his scrapbooks Yunkers listed several American artists and offered a comment:

> Behold the suicides of extraordinary artists in the U.S.A. not being able to avoid the sharp edges of the "American dream." Dreaming of a much bigger and less muddy dream;
> Gorky,
> Pollock,
> Smith,
> Rothko, etc.
> All of them
> And each one—
> A confession
> With an element of revenge.[34]

Following his own path, Yunkers created in the early 1960s four large works derived from Chinese proverbs: *Hour of the Dog* (Museum of Modern Art, New York), *Hour of the Monkey* (private collection, Cleveland), *Hour of the Horse*, and *Hour of the Bullfrog*. Yunkers was interested in Chinese and Japanese calligraphy, but he had not yet referred to it as consciously as he did in his *Hours*. He took from Japanese calligraphy that which was most appealing to him—the possibility of being both spontaneous and in control while creating a rhythmic abstract drawing that also functioned as writing. Yunkers no doubt enjoyed the feeling of making art and "writing" at the same time. In the *Hours* pastels he achieved an unprecedented level of fluidity and a dynamic harmony that resulted in a balanced motion. His technique consisted of spraying the paper with water and fixatives before applying a compound of pastel chalk and liquid gouache with large brushes. Some parts of the images were painted with gouache only, forming areas of more thickly applied colors. The effect was dazzling, with translucent and opaque areas weaving into each other, creating an abstract play of chiaroscuro occasionally "disturbed" by small areas of other colors.

Color was further reintroduced in a number of works titled *Messenger* or *Secret Messenger*. The pastel *Secret Messenger I*, 1961, was preceded by a large charcoal

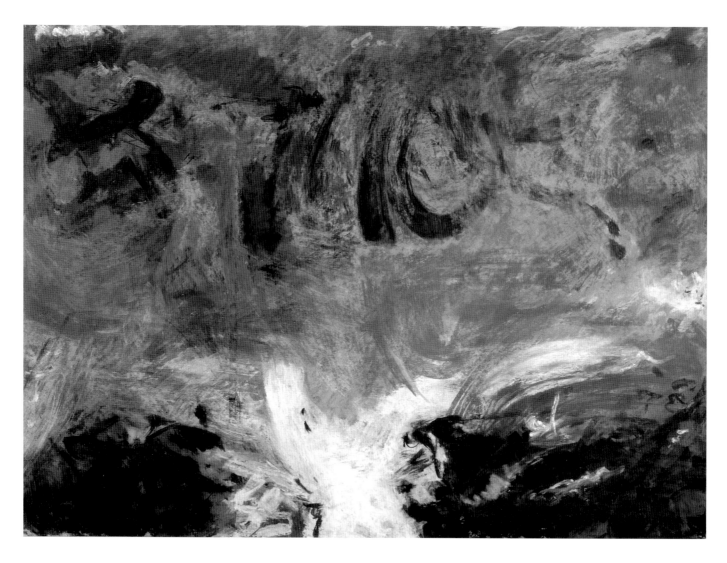

Hour of the Horse, 1962,
pastel and gouache, 47 × 65 inches.
Private collection, Cleveland.

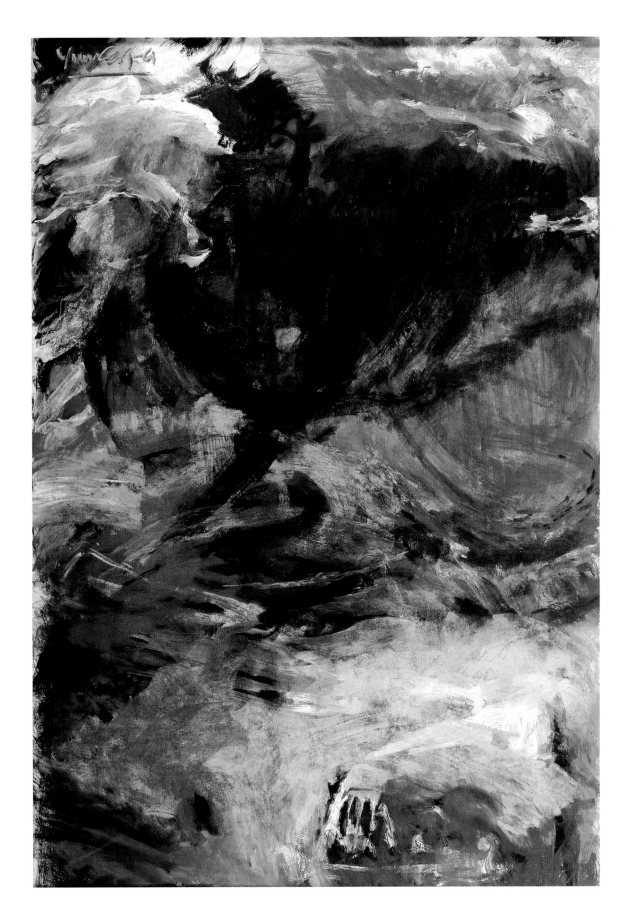

Hour of the Bullfrog, 1961,
pastel and gouache, 69 × 47 inches.
Collection of Dore Ashton.

Le Paysage aux Alouettes, 1962
(from the *Messenger* series),
pastel and gouache, 48 × 44 inches.
Private collection, Cleveland.

drawing on canvas titled *Messenger* and a large gouache titled *Secret Messenger*.[35] The gouache has a similar composition to the drawing—three dark, barlike forms are placed in the middle against a lighter, more vaporous background—but the gouache is more gestural and spatially ambiguous. The pastel is more structured, with the three vertical shapes slightly tilted to the left, looking like burning candles. *Secret Messenger II*, 1962 (private collection), eliminates figurative references by replacing the three bars with a large rectangle, which with its frontal presence looks like the painting's "dead area." *Untitled*, 1961 (from the *Messenger* series), juxtaposes a dark, feathery form that hangs in the middle of the picture with a red one placed to its left. The two forms are painted in long, sweeping movements that contrast with the green and pink background, which is executed in short, nervous brushstrokes. *Untitled*, 1962 (from the *Messenger* series), which has a bold shape placed against a field of lighter colors, is reminiscent of Claude Monet's paintings of France's northern shores. (The Abstract Expressionists rediscovered Monet in the 1950s.) In addition, both of these untitled works have the effect of an upside-down hanging, similar to the one Morris Louis used as a device for liberating the image from gravity in his *Veil* paintings of 1958.

In *Polish Messenger*, 1962 (private collection, Cleveland), Yunkers returned to the lighter palette of salt prints and used more airy space. The work's title may be linked to Rembrandt's *Polish Rider*, as well as to a trip Ashton made to Poland in 1960 with curator Peter Selz to organize a show of contemporary Polish painting for the Museum of Modern Art in New York. In 1961–62 Yunkers also made a series of pastels titled *Git le Coeur*, which derives its name from a street in Paris. Yunkers told an interviewer:

> We [he and Ashton] were in Paris . . . and it was raining as usual. . . . So I took the street dictionary, the little red book, you know, and I started reading it from A to Z, the names of the streets. Suddenly I discovered that though I had lived for fifteen years in Paris I had never bothered to notice the fantastic poetry in the names of the streets—L'impasse des anges, and so on and so forth, and I wrote them down.[36]

A ghostly work titled *Le Paysage aux Alouettes*, 1962, from the *Messenger* series, is considered to be Yunkers's last pastel. It has the appearance of fragility, with small white forms arranged in a boundless composition that appears to dissolve as it approaches the picture frame.

In 1962 Yunkers's pastels from the previous year were gathered together in a small retrospective at the Stedelijk Museum in Amsterdam, and a show of his new pastels opened at André Emmerich in New York in November.[37] Many have agreed that Yunkers had taken the medium of pastel to an unprecedented level, proving, as Henning has noted, "that in the hands of a real artist there is no such

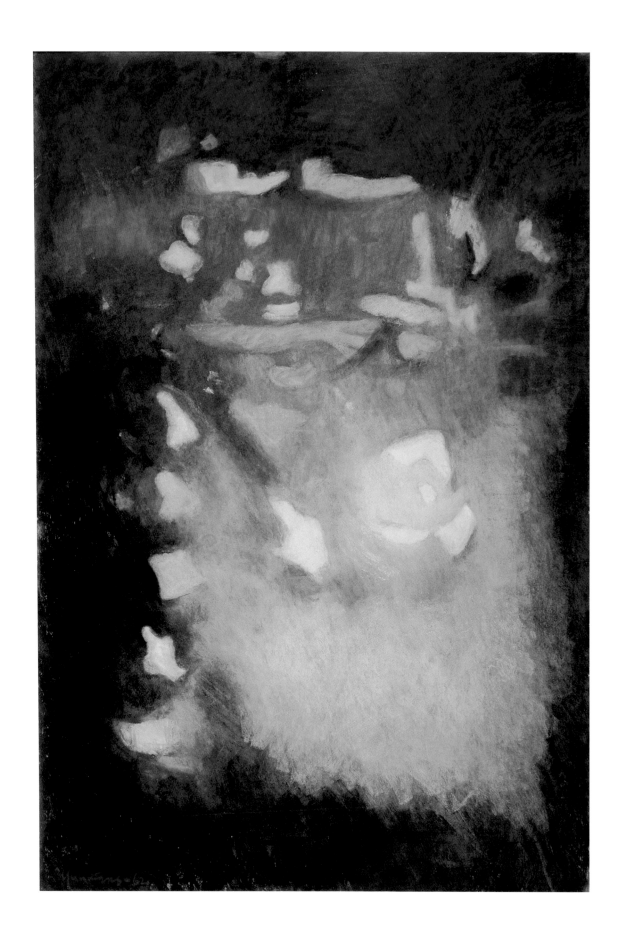

thing as a minor medium."[38] But then, at the height of his success, Yunkers decided to abandon pastels. He commented on his decision:

> You see, one of my characteristics is that I hate to plagiarize myself. When I can't do things, when I've sort of absorbed the material and seen what I can do with it; in other words, when I've squeezed everything out of it and then there comes a point when I can do those things in my sleep; from that moment on I just lose any interest whatsoever. . . . suddenly at a certain point I got so sick and tired of this lushness and all this color, and it coincided with the death of expressionism somehow on an emotional level. Although I didn't think of it, but this lushness made me really seasick. Suddenly I had this longing for herring, black bread, you know, for rigid discipline. And I just gave it up.[39]

The year 1962 was also when Yunkers distanced himself from André Emmerich. He had been with the gallery for almost six years, but he felt that he was treated as a less important artist. He would show with Emmerich in 1963, but the relationship between the artist and the dealer was not harmonious. Yunkers's conflict with Emmerich had its consequences. In the following years he would go through a number of different galleries, but none of them was as influential as Emmerich had been.[40] Still, Yunkers was by this time recognized as an important American artist. *Art Voices,* an independent art magazine, published a large photograph of Yunkers by Marvin P. Lazarus, calling him "a leading American abstract expressionist" and "one of the giants of the New York School."[41] Brian O'Doherty finished his *New York Times* review of Yunkers's show at Emmerich with the assertion: "His performance in these large pictures is controlled, quiet, and exquisite."[42] Georgine Oeri wrote in *Art International:*

> Paul Valéry once said that poets are persons who "are not much more profoundly touched than anyone else by what touches everyone . . . but . . . who are extremely moved by things that move no one else." They are, as a matter of condition, in the state of "irritable richness." Adja Yunkers has the make up of such a poet.[43]

Yunkers's popularity did not escape the critical eye of other artists. In the 1965 book *Vanguard Artists: Portrait and Self-Portrait,* one of the quoted artists noted that Yunkers's works had become desired by institutions looking for "special titillation" and "novelty": "Even hidden places like the Cleveland Museum suddenly buy Klines and Yunkers—just to make it, to be modern, to pull in the crowds."[44] In the catalogue for the exhibition *American Prints Today/1962,* which toured major museums in the United States, Yunkers responded confidently to these voices: "The content of my graphic work stands for what I am and not what I intend to be."[45]

Chapter 5

The Community of Artists and Poets

The world is contained
In sixteen syllables
You in this hut

—Octavio Paz, after visiting Bashō's hut near Kyoto[1]

A few pages back we discussed poems that sing of breath and wind houses, poems which
seemed to have attained the ultimate degree of metaphor. *And here we see a poet who*
follows the working draft of these metaphors to build his house!

—Gaston Bachelard[2]

Art was not Yunkers's major preoccupation for the period following his shows
at the André Emmerich Gallery in 1962 and 1963. The year 1963 was mostly
spent setting up his new house on Manhattan's East Eleventh Street and spending
time with little Sasha Yunkers, his and Ashton's first daughter, who was born in
September 1962.[3] Lacking a studio, Yunkers had to work at home, which might
explain why he made only smaller pieces and returned to woodcuts. As if respond-
ing to changes in the aesthetic taste of the early 1960s, which went against Abstract
Expressionist sensibility and technique, Yunkers returned to printmaking, treating
it as an intimate form of expression. Judging by a recently discovered work from
this period, that year must have been quite a difficult one in Yunkers's life. The
small gouache, lacquer, and pastel on cardboard titled *Saudades III*, 1963 (Estate
of Adja Yunkers), is one of the most disturbing works of his career. The painting
has a deep violet rectangle "floating" on a light purple background. The dark
rectangle is crossed with black bars like a prison window. The only bright accent
is a small red dot placed at the upper right of the picture. The image is somber and
aesthetically displeasing, as if Yunkers had lost the "lightness" of his earlier works.

In 1964 Yunkers was a visiting lecturer at the University of Hawaii in Honolulu;
he found that he disliked Hawaii for being "too lush . . . like a greenhouse" and for
producing laziness.[4] Perhaps reacting to the abundance of "lushness" in his earlier
pastels and to the busy schedule of his life, Yunkers retreated to modest ink draw-

ings and gouaches. His stylistic transformations during this time can be traced in a number of little-known works, which Yunkers treated as experiments in different media. Two of his ink drawings from 1964 were included in an international exhibition in Darmstadt in September of that year.[5] *Drawing I* (whereabouts unknown), in its arrangement of bold forms against a dark background, recalls the *Skies of Venice* prints or the *Tarrasa* pastels. In contrast, *Le Dahu II* (whereabouts unknown) is Surrealistic, depicting an arm with a brush instead of a hand, formed to suggest an erect penis emerging from an oozing darkness. The title refers to a fantastic horselike creature, *le dahu*, with its two right legs longer than its two left legs, taken from a French children's story. Another work from this period, the color woodcut *Veronica I*, 1964 (Estate of Adja Yunkers), has the downplayed colorist sensibility and dreamlike translucency of the *Ostia Antica* prints, but its formal blocky arrangement, with a phallic quality, is similar to *Composition in Black and Ocher (3-11-57)* and related to the print *Composition N–1957* (private collection, Cleveland). The collage *Black and White #2*, from 1964 (but dated 1965 on the reverse; Estate of Adja Yunkers), consists of a rounded black form, looking like a massive head or rock, and two parallel horizontal strips of torn paper pasted to the board at the lower-right corner. In *Nameless Places*, 1965 (Estate of Adja Yunkers), Yunkers returned to the gestural but in a more minimal way. The acrylic on canvas is painted in flesh pink, with a small winglike shape in black and white suspended at the upper center. *Summer in Venice*, 1965 (Estate of Adja Yunkers), has a similar composition, with a dark, armlike shape in the bottom center. Both paintings are rather static and more hard-edged than Yunkers's previous works.

Yunkers fully regained creative energy when in early 1966 he was awarded a commission to paint a mural at Syracuse University. His commission was part of the university's ongoing acquisition program, begun in 1958 with the gift of Rico Lebrun's 1950 *Crucifixion* from the Whitney Foundation. Yunkers was the seventh artist to be invited by the university since 1960.[6] He titled his work *A Human Condition*, with a subtitle taken from Tacitus's *Life of Agricola:* "They have made a desert and they have called it peace." In a press release issued by the university, Laurence Schmeckebier, dean of the School of Art, described the mural in safe, general terms:

> Its meaning and interpretation depend as much on the creative participation of the spectator as on the visual statement of the artist. It does not tell a story. It is not an illustration. It is neither a *Crucifixion* nor a *Guernica* nor a social protest, but a contemporary artist's statement of a present-day state of mind which is an emotionally human and spiritual condition. It is large in concept, tremendous in size [50 by 17 feet] and unbelievably simple in its final execution.[7]

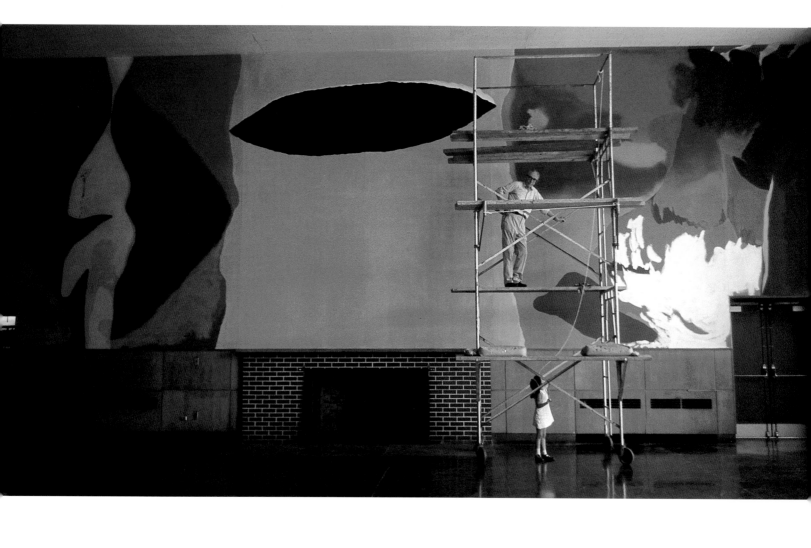

Page from a scrapbook with a photograph of a burning Buddhist monk. Museum of Modern Art, New York.

Yunkers's ideas for the mural are revealed by a journal he kept while working in Syracuse. On its front page he wrote, "Un mur en face de moi, c'est mis à reculer" (A wall in front of me started to move back). Opposite the title page he pasted the famous photograph of a seventy-three-year-old Vietnamese Buddhist monk, Superior Thich Quang Duc, who set himself on fire in Saigon on June 11, 1963, protesting the American-backed government's discrimination against Buddhists. Responding to the picture's horrifying directness, Yunkers wrote in his journal:

> All around, the horizon burns with the color of death.
> As for me, yes, I am still alive,
> But my body and my soul in it writhe as if they too
> Had been set afire.
> My parched eyes can shed no more tears.[8]

Yunkers described his vision of the mural: "1966. Mural at Syracuse University 'The Human Condition' 35 × 50' [*sic*]. Left panel is the flame within which the first Vietnamese monk burned himself by pouring gasoline on himself. The center panel is 'Napalm at Noon' and the panel At the right is the devastation by planes 'The Anonymous Death: U.S.A.'" Yunkers's description alludes directly to the criticism of the American invasion of Vietnam. He explained the thoughts that accompanied his work:

> While I was doing the painting, I had ample time (10 hours a day) to think and I came to the conclusion that a burning monk is not very exciting; not the act itself, but what preceded the act, a state that was itself filled with dignity and serenity. My problem, therefore, was to solve it in such a manner that it projects the same serenity and dignity—and of course—the conciseness as a mountain peak might have. I believe I succeeded in conveying just that. The form in the left panel representing the mass of monks in a diamond shape as [in] a western (my) conception of a Buddhist mandala torn in half by a yellow form.[9]

In a letter to Ashton postmarked June 23, 1966, Yunkers described his working process, which consisted of drawing individual forms with charcoal on thick drawing paper cut to the size of each panel. Because the forms were large, he had to work on the floor. After he cut the forms out, he fastened them onto the canvas with masking tape and outlined them on the canvas. He commented:

> It's a heck of a work to draw such large forms on the floor (how Motherwell could paint his mural on the floor is inconceivable to me). When you do this sort of work on the floor the sweep of a line of necessity becomes contrived since it is not normal to draw horizontal instead of vertical—at any rate, I did rather well and when all the forms will be outlined on the canvas—I will be able to correct and substitute the willed sweep for a natural and spontaneous one.[10]

The work on the mural was difficult. Yunkers complained about problems with the workers and small accidents on the scaffolding, and he reported that he was struggling to make his mural "simpler, stronger and more convincing," achieving the "maturity of a mountain peak" (letter dated June 7, 1966). Two weeks later, in a letter to Ashton dated June 21, 1966, Yunkers seems to have triumphed over the difficulties:

> One thing I must tell you; when confronted with the wall today—I felt like a bullfighter might feel seeing the bull rushing out of the pen, sizing him up and being relieved that at least it wasn't a cross-eyed bull—well—the wall doesn't frighten me anymore and I looked at it rather with a lopsided grin, thinking: well, I'll show you, you bastard!—I'm not going to perish alone; if we have to go down, we both will—you and me!

The mural made a strong political and artistic statement. Yunkers saw himself as a serious artist who would naturally want to create a wall painting that would rival the power of Picasso's *Guernica* (1937) or the works of the Mexican muralists. In a letter to Paul (last name unknown) dated June 12, 1967, Yunkers confirmed the message of his work: "as the title on back of the pictures indicates—the pictures bear relation to the Vietnam War." Today, Syracuse University's web site mentions *A Human Condition* as possibly

> the most politically charged mural on campus since it was an artistic statement that included references to a specific event . . . to the self immolation of a Buddhist monk in 1965 [*sic*]. This supreme act of protest gained worldwide attention as did the napalm bombing of villages during the early stages of the Vietnam War.[11]

Yunkers tried in *A Human Condition* to fuse political references with the modern tradition of wall painting, formally connecting his work to Henri Matisse's late cutouts, such as *The Beasts of the Sea*, 1950. (Matisse was one of his favorite artists.) The Vietnam War coincided with the beginning of Conceptualism with its preference for ephemeral media, provoking what Lucy Lippard called "downward mobility of the counterculture and the theoretical focus of the often academic New Left."[12] In the eyes of younger radical critics and artists, it had to seem, therefore, as though in his mural Yunkers was subscribing to a questionable practice of making "precious objects."

Yunkers felt he was moving his art into a new direction, while ignoring Conceptualism. He stubbornly believed that art could be a "commodity" and yet continue to have its *raison d'être*, both aesthetically and as a valid political and cultural comment. After finishing the mural, Yunkers began work on a new series of paintings titled *Aegean*. He started with small gouaches and acrylic-and-collage or oil-and-collage paintings, such as *To a Poem of Mayakovsky*, 1966 (Estate of

Henri Matisse, *The Beasts of the Sea*, 1950, paper collage on canvas, 116⅜ × 60⅜ inches. National Gallery of Art, Washington, D.C., Ailsa Mellon Bruce Fund.

Adja Yunkers), in which he experimented with an austere arrangement of abstract forms composed of torn paper, recalling *A Human Condition*. One of his paintings, *Homage to the Monks of Vietnam*, 1965–67, closely recalls his mural with its arrangement of cutout-looking forms. These new works demonstrate a decisive push toward a minimal type of expression. What Yunkers probably liked in Minimalism was its quality of "plain speaking" and stylistic clarity, which he considered quintessentially American. His "pictorial Minimalism" was, in fact, close to its early definition by John Graham in "System and Dialectics in Art," first published in 1937:

> "Minimalism" is reducing of painting to the minimum ingredients for the sake of discovering the ultimate, logical destination of painting in the process of abstracting. Painting starts with a virgin uniform surface and if one works ad infinitum it reverts again to a plain uniform surface (dark in color), but enriched by process and experiences lived through.[13]

Yunkers's 1967–69 *Aegean* series (in various private and public collections) consists of large "white" acrylic paintings (numbered I to XV), cut-and-pasted-paper dark oil collages (numbered I to XVI), embossed color lithographs (including *Aegean II—Portrait of D. as a Young Girl and as a Mature Woman*, 1967), and collage-serigraphs.[14] In his large paintings Yunkers used a technique similar to the one he experimented with in *A Human Condition:* he first pasted large, irregular pieces of cutout white canvas onto the white canvases, then painted a few irregular stripes in blue, yellow, brown, or pink, often stretching them along the length or edges of the canvas. "I have one patch of blue, maybe one line of blue or one line of yellow," Yunkers commented on his new paintings in 1969, "and now there's clarity, there's simplicity, there's control and all the same plastic stripes are pure color."[15] A few years later, Harold Rosenberg elaborated on Yunkers's collage-derived *Compositions*, 1970–71, presented at that time at the Whitney Museum of American Art in New York: "For Yunkers, strips of painted paper provide a restrained variation of the surface that could not quite be matched by built-up strands of pigment; that is to say, he uses collage to obtain a formal low-relief figure on a flat ground."[16]

Aegean I, 1967, is a large painting with two blue strips at the peripheries of the image that frame the space into an open arena of visual contemplation. Yunkers contrasted the ultramarine blue of the stripes with a white background delicately shaded with pale grays, yellows, and pinks. In *Aegean III,* 1967, Yunkers reduced the presence of shapes to two triangular ones, a yellow and a dark blue, further enhancing the contemplative Minimalist aspect. In *Aegean IV,* 1967, a blue strip is placed at the upper right, cutting across the space with great authority but making its presence almost ethereal. Edward B. Henning saw a continuity in Yunkers's

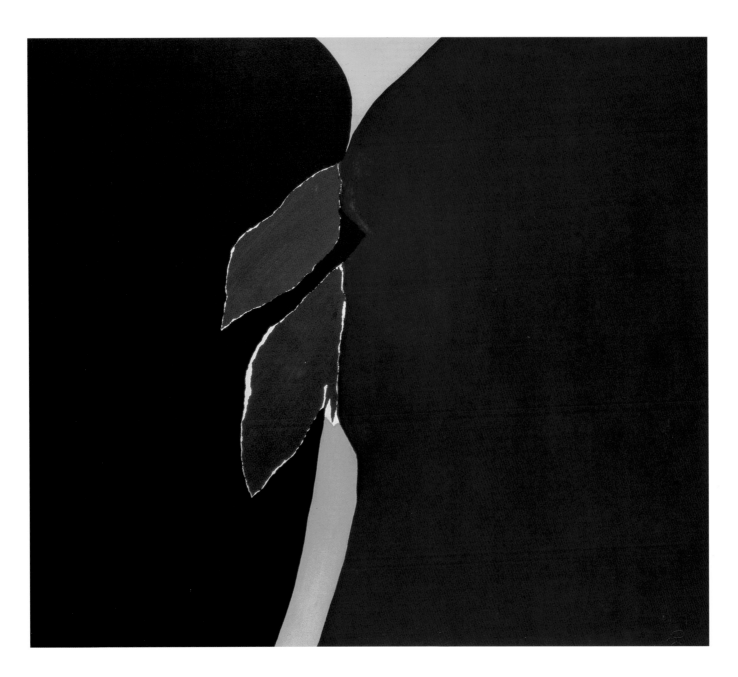

Homage to the Monks of Vietnam,
1965–67, oil and collage on
canvas, 62½ × 73 inches.
CDS Gallery, New York.

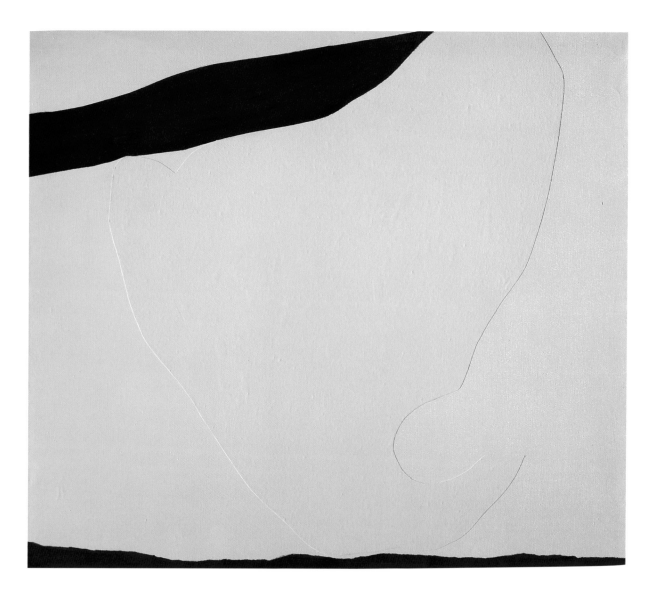

Aegean I, 1967, acrylic and collage
on canvas, 62¾ × 72¼ inches.
Cleveland Museum of Art, Gift of
Dore Ashton.

works, "despite their purity and simplicity," with the subjectivity of his images
from the Abstract Expressionist phase.[17]

The *Aegean* prints successfully translated collages and paintings to the media of
lithography and serigraphy. The print *Aegean I* appeared in a portfolio titled *Artists
and Writers Protest against the War in Vietnam*, published in 1967 by Artists and
Writers Protest Inc. Sixteen artists contributed prints, including Mark di Suvero,
Louise Nevelson, Ad Reinhardt, and George Sugarman. The works in the port-
folio, which was a voice of protest against the brutality of war in general, ranged
from abstractions to a photographic image of a Vietnamese mother with her
children.

Yunkers attained further professional recognition in the early 1970s. He had already consolidated his reputation as a major American printmaker by having a print retrospective at the Brooklyn Museum, accompanied by a monograph written by Una E. Johnson, in 1969. He had a show at the Whitney Museum of American Art in New York in 1972, as well as a number of exhibitions all over the United States and in Mexico and Venezuela. In 1974 he had a one-person show at the Zabriskie Gallery in New York in which he exhibited, among other works, a *livre de luxe* titled *Blanco,* 1974, a collaboration with the poet Octavio Paz.

Blanco was in many ways the culmination of a faithful friendship between Yunkers and Paz. Yunkers remembered meeting Paz in Paris in the late 1930s and then with Ashton in the early 1950s.[19] In the late 1950s the couple saw Paz while they were traveling in Mexico to visit the sculptor Mathias Goeritz, whom Yunkers knew from Europe. They continued to meet each other on various occasions, including in Paris in 1960. Yunkers said that he and Paz had three things in common: "a belief in fatalism; a taste for metaphysics; and the analogy of Russian--Scandinavian and Mexican folk art."[20] In October 1968 Paz wrote the poem "Mexico: The XIX Olympiad," which appeared in the November 7, 1968, issue of the *New York Review of Books.* Dedicated to "Dore and Adja Yunkers," the poem expressed friendship and thanks for their active role in condemning the massacre of a student in Mexico City. Paz's notice of resignation from his post as ambassador to India in reaction to the handling by the Mexican government of uprisings in Mexico City accompanied the poem. Yunkers remembered that after Paz came to New York,

> We had an evening here where Octavio Paz was reading his poems. There were a number of invited guests who paid ten bucks. We collected quite a lot of money that way. Those who could not come sent checks to Dore. It all went to Mexico for the imprisoned students there, that's why we did it.[21]

When *Blanco* was printed, Paz was a resident at Harvard in the Department of Romance Languages. His poem "Blanco" is a tribute to his wife, Marie José, and was written in India in 1966, when he was the Mexican ambassador.[22] The poem in the portfolio is accompanied by two epigrams, one Hindu, one French: "By passion the world is bound, by passion it is released" (The Hevajra Tantra) and "Avec ce seul objet dont le Néant s'honore" (Mallarmé) (With this single object Nothingness respects itself.). The portfolio has an introduction by Roger Shattuck, then professor of French at the University of Virginia, Charlottesville, in which he writes:

> A poet who has traveled through many countries of the mind, Paz has had two guides in his exploration: Mallarmé and Duchamp. The gentle French poet staked the ultimate intellectual claim of all times in a single sentence: Everything in the world exists to end up in a book. Duchamp, equally astute and

Yunkers with Octavio Paz, opening of an exhibition, 1974. Photograph courtesy of the Estate of Adja Yunkers.

A pulse-beat, an insisting,
Surge of wet syllables.
Without saying a word
My forehead darkens:
A presentiment of language.
Patience patience
(Livingston in the drought)
River rising a little.
Mine is red and scorches
among flaming sand-heaps:
Castles of sand, broken playing-cards
And the hieroglyph (water and coal)
On the chest of Mexico fallen.
I am the dust of that earth.
River of blood,
 River of histories
Of blood,
 Dry river:
Mouth of the source
Gagged
By the anonymous conspiracy
Of bones,
By the grim stone of centuries
And minutes:

Two pages from *Blanco*,
1974, *livre de luxe*.
Estate of Adja Yunkers.

 Language
Is an expiation,
 Propitiation
To him who does not speak,
 Entombed,
Assassinated
 Every day,
The countless dead.
 To speak
While others work
Is to polish bones,
 To sharpen
Silences
 To transparency
To undulation,
 The whitecap
To water:

5

Collage for *Blanco*, collage on canvasboard, 1974, 30 × 40 inches. Estate of Adja Yunkers.

O. Paz. *Y.*

more gifted than Mallarmé as an engineer, considered a book to be a machine for producing meaning. Haunted by these two statements, *Blanco* remains a dark utterance, fourteen interlocking poems in search of an artist, until Yunkers created their apparatus, their white box.[23]

Yunkers chose Baskerville type for *Blanco,* embossing parts (sometimes in reverse) of the scattered text, and using lithography for Paz's poem. He produced embossed lithographs and silkscreens, supplementing them with collaged and hand-painted elements. The *livre deluxe,* produced in fifty numbered and signed copies, consists of double-page spreads, with the last spread devoid of text and image: white on white, or as Paz described it in a Mallarméan fashion, "a passage from blank to white."[24]

Blanco was in fact not the first collaborative project between the two; in early 1969 Yunkers and Paz had worked together on *Poems for Marie José*, a handsome portfolio of five prints by Yunkers on Arches paper, numbered and signed, accompanied by five poems by Paz that were dedicated to his wife, translated from Spanish into English and French. Yunkers included his silkscreen versions of *The Couple in Black and Purple,* 1969, and *Aegean II—Portrait of D. as a Young Girl and as a Mature Woman,* 1967, and three embossed lithographs, including one based on an *Aegean* and one on an *Illusionist. Poems for Marie José* produces a dialogue between the artist and the poet about love for the women in their lives. In the sensual poetry of Paz, Yunkers's artistic expression found the perfect match:

> Over the reverberations of the wall
>> Vertical salt-pan
> Petrified blue violence
>> Incessant fall
> Of the curtain (Behind it

The sun battles the sea
 The tile floor
Breathes in breathes out
 The window table/bed
Now the blue stretches extends
 Sustains
A rose plow A girl
Her dress burnt lac still warm
 Eyes
Half-closed not for expectation
 For the visitation[25]

In the early 1960s Yunkers had produced a unique, large *livre deluxe*, titled *Stanley Kunitz: Selected Poems, 1928–58* (Museum of Modern Art, New York), using brushed lettering and pastel and painted illuminations, which he dedicated to his daughter Sasha. In 1976 he made another portfolio of prints to poems: *On the Marginal Way* with the poems of Richard Wilbur. *Blanco,* however, remains his masterpiece in this genre.

Friendship and collaborations with Paz were obviously expressions of a broader aspect of Yunkers's outlook on life.[26] He had always felt a deep affinity with poets—those whom he knew personally, like Loynaz, Kunitz, Paz, Wilbur, Kathleen Raine,[27] Robert Lowell, and others; and those whom he read passionately: Shakespeare, Rilke, Esenin, Mayakovsky, Stéphane Mallarmé, Paul Valéry, Federico García Lorca, and Pablo Neruda. He grew up reading poetry in Latvia and Russia and looked for poets and writers in Berlin. When he left for Cuba, he took with him a volume of Rimbaud's poetry that he kept throughout his life. He knew Swedish Surrealist poets. When he came to the United States, poets and writers were among his good friends. He brought with him a large reproduction of Mallarmé's portrait. He kept a reproduction of a photograph of D. H. Lawrence from 1924, taken by Edward Weston. And on the wall of his studio at 821 Broadway he wrote, after Charles Baudelaire and Matisse: "Luxe, calme et volupté."[28]

Paz showed another proof of his friendship in 1979, when he wrote about Yunkers in the January 1979 issue of *Art International*. "The object of Yunkers's extreme asceticism," Paz argued, "is to restore transparency to a painting. In spite of its eroticism and its lyricism, his painting is decidedly anti-psychological. Relations not of the painter's soul or ego, but of space."[29]

That issue of *Art International* honored Yunkers with text by Paz and a long article by the critic and historian Andrew Forge. Forge wrote: "He is 78. Each day in the studio is weighted now. 'I am not interested any more in fishing around.'"[30]

Chapter 6

Reaching for Silence

There can be no thought of death, there is only the anguish at ceasing to exist and this gives body to the threat of death. One must therefore regard death as unthinkable, as impossible. The revelation is that nothing can be revealed.

—Adja Yunkers[1]

By the mid-1970s Yunkers had changed his art and life for the final time, again reinventing himself with great determination and intensity. He made hundreds of paintings, returning again and again to the motifs that had symbolic significance for him: the lovers, the abstract landscape, and the black square. He also made a series of intaglios, based on his collages, at Styria Studio in New York, in which he achieved an impressive relief presence by etching plates over many days.
In works such as the *Song of a Lonely Bird* series, 1974–75 (various collections), Yunkers turned to a darker palette and earthy colors, staining his paintings, rather than painting them, in an expressive manner.

He reengaged in a dialogue with Malevich. Yunkers was not a religious person, but religion was part of his aesthetic outlook on life. Like Malevich, he was able to bridge the spiritual and the aesthetic by embracing the cosmic dimension of space and perceiving the canvas as a window through which we discover and experience life. In 1975 Yunkers created a triptych consisting of three large monochromatic paintings: two pink "wings" and a black center (Estate of Adja Yunkers). He also executed a number of paintings titled *Icon*, with consecutive numbers. Some of them are static, serene geometric compositions, while others offer cosmic, immaterial views of the sky or microscopic pictures of blood cells and cancerous regions on human skin.[2]

Yunkers's "dialogue" with Malevich was now intense, as evidenced by both the significant number of works with "Malevich" in their titles and by the images themselves. In 1975 he created *The Grave of Malevich*, which has a U-shaped string attached to the canvas. (Yunkers began to use strings in his paintings in the mid-1970s, as in the acrylic and collage *Endless Things*, 1975 [Estate of Adja Yunkers], with its rows of horizontal strings of various lengths.) His later acrylic and collage *Grave of the Malevitch*, 1975–76, plays with the idea of a square within a square (or rectangle) by placing a gray-white vertical rectangle on a pastel yellow back-

Icon X, 1978, acrylic and collage
on canvas, 42 × 52 inches.
Estate of Adja Yunkers.

ground and delineating it with thin pieces of pasted wood. The second rectangle
(in a different shade of off-white) is painted inside the gray-white form. Yunkers
textured his works by adding sand to his paints. For him these means of expression
showed that Malevich's more minimal approach was a cul-de-sac. As the titles
suggest, Yunkers seemed to be working in these late years of his life to free his
art from Malevich's influence, which had been with him for so long. But he later
explained: "Three years ago, I painted 'The Grave of Malevich.' I was able to do
that because of my own development, spiritually and intellectually. He was all my
life with me, because I found him superbly adventurous, so revolutionary."[3]

The Grave of Malevich, 1975, acrylic
and collage on canvas, 80 × 67 inches.
Museo de Bellas Artes, Caracas.

Grave of the Malevitch, 1975–76,
acrylic and collage on canvas,
80 × 67 inches.
Private collection, Cleveland.

June 10, 1977, 1977, acrylic and collage on canvas, 52 × 48 inches. Estate of Adja Yunkers.

In 1977 Yunkers and Ashton separated, and the artist responded to the personal crisis by creating the white-on-white mixed-media work titled *June 10, 1977* (the date of their separation), which with its reference to Malevich's white-on-white paintings suggests that Yunkers was attempting to symbolically put his relationship with Ashton behind him through his art. At the same time Yunkers was beginning to resurrect memories from his childhood through his paintings. He explained that "the past started to creep up. I never could remember much before the age of 7. Suddenly I remember the age of 3: father and mother, neighbors, a house and a garden on an island that went down to the river."[4] In 1978 Yunkers created *To Invent a Garden,* a painting with a horizontal arrangement of strings placed on an ocher "formless" background, which followed another painting that referenced the artist's childhood: *My Childhood Garden on Vassilevsky Ostrov,* 1976–78. This painting, which Yunkers endowed with a sense of quiet reverie, suggests affinity with numerous mythical and "real" places filtered by imagination. Although Yunkers had stated that he was no longer interested in the development of artistic styles, he obviously had stored in his memory a great visual culture that inevitably found its way into his art. *My Childhood Garden on Vassilevsky Ostrov* is like a blackboard covered with paint and graffitilike drawings. It is a child's fantasy of a distant, safe place that lost its materiality and became a misty memory but did not lose its colors.

The painting *Doors to Memory,* 1977 (private collection), also has the rectangle-in-rectangle composition, but replaces the strings with four rows of flowerlike embossments. Its geometric forms arranged in a decorative pattern saturate the image with an Oriental mood. Yunkers's archives contain the painting's direct source of inspiration: a color postcard he brought from Turkey of a seventeenth-century Gordes carpet. He closely reproduced the image on the postcard, in which he had found one of his favorite motifs—the rectangle—rearranging the carpet's floral element into rows. The idea for the range of embossments might have come from another color photograph that the artist kept in his studio: a picture of indigenous architecture from Santa Fe and Taos.[5] At this point in his career Yunkers must have felt comfortable borrowing any motif that caught his attention. When his rope paintings (as they have often been called) titled *Cameroon* (various private and public collections) were presented at the Alice Simsar Gallery in Ann Arbor, a reporter from the *Detroit Free Press* found them to be "permeated with the scenes of African ritual . . . bouncing with the loud-soft-soft rhythm of some timeless chant—primordial emotion in modern garb." Being used to such free interpretations, Yunkers told the reporter that he connected with the experiences of other cultures by "kneeling down in oneself and listening; for if you listen well you'll succeed in making pictures that are like you."[6] Paradoxically enough, the photograph that accompanies the article shows a handsome older man wearing glasses and smoking a cigarette; the caption below it reads: "Adja Yunkers: Always leading the avant-garde."

My Childhood Garden on Vassilevsky
Ostrov, 1976–78, acrylic, sand, and
collage on canvas, 72¼ × 62½ inches.
Estate of Adja Yunkers.

To Invent a Garden, 1978, acrylic
and collage on canvas, 70 × 60 inches.
Private collection.

By this time Yunkers had produced a large body of work with strings attached to their surfaces. *Bal des Pendus V,* 1977 (Estate of Adja Yunkers), is one of several large paintings with the same title and consecutive numbers, in which rows of twisted vertical ropes create a sense of menace and sadness. *Rice Paddy,* 1977 (private collection), has three rows of vertical strings packed tightly to form a graceful rectangular image. The rope paintings may have been connected to Yunkers's interest in "antiaesthetic," time-worn materials and material-oriented techniques, such as collage, assemblage, and graffiti, a sensibility that he had developed in the 1960s, sharing it with many artists, among them the Europeans Antoni Tàpies and Alberto Burri. Works of Tàpies, such as his *Circle of Rope,* 1969, share with Yunkers's art a desire to endow found materials with Minimalist presence, while retaining their viscerality. There was, however, a more dramatic reason behind Yunkers's new technique in the late 1970s. The use of strings also came about as a result of his fading eyesight, which was making his work increasingly difficult and required more tactile materials to work with.

After separating from Ashton, Yunkers began to feel isolated from the art world in New York and left for San Francisco in late 1978. He exhibited mainly outside of New York, particularly in South America where his art had gained serious recognition. He had, for example, a major show in 1979 at the Museo de Belles Artes in Caracas, Venezuela, where he was honored by receiving a congratulatory telegram from the president of Venezuela, Carlos A. Perez.[7]

Yunkers returned to the East Coast in 1980, settling in a studio apartment on Front Street in downtown Manhattan. In 1982 he had large print shows at Albion College in Michigan and Miami University in Oxford, Ohio, and presented his new rope paintings at the Allrich Gallery in San Francisco and the CDS Gallery in Manhattan. He discussed his rope paintings with a journalist from the *New York Post:*

> I had to find an answer to my need for expressing myself. I had to find a way I could touch and feel and know. So that's how I came to the strings. . . . I call them jokingly, "No Strings Attached." . . . Apart from everything else, my friend, I never could understand artists who find a little idea and then carry it out for the rest of life. This to me is masturbation. I get bored. So I must always go to something new. Which to me simply means trying to get better—better man and better artist. . . . Eventually, I will have to give up painting and go to sculpture.[8]

Antoni Tàpies, *Circle of Rope,* 1969, mixed media, 65 × 65 inches. Anderson Gallery, Inc., Buffalo, New York.

Bal des Pendus V, 1977, acrylic and
collage on canvas, 74 × 52 inches.
Estate of Adja Yunkers.

Purloined Letter, 1981, collage
and acrylic on canvasboard,
20 × 24 inches.
Estate of Adja Yunkers.

Yunkers's health was deteriorating quickly. He had become blind in his right eye, and soon he began to suffer from emphysema. His eyesight forced him to give up painting in 1982, and although he continued working on his art until his death in December 1983, he made only collages in the last year of his life. In one of his last paintings, *A Painter's Love V*, 1982 (Estate of Adja Yunkers), which derives from other paintings with the same title and different numbers, such as *A Painter's Love II*, 1981, Yunkers included the red dot that had made its way into so many of his works as a cipher of his childhood fears, this time placing it below a long vertical line, creating an exclamation mark.

During his last years Yunkers exchanged letters with his children, and he maintained contact with Ashton. He arranged his numerous scrapbooks and wrote poetry. On January 31, 1983, Yunkers wrote this poem:

> yesterday
> today
> these
> old—
> curious
> endless
> roads[9]

In April 1983, nine months before his death, Yunkers expressed the thoughts that accompanied him toward the end of his life:

> My concern is with silence now, the philosophical conception of the power of silence and how you plastically represent silence. I finally came to the conclusion that every political ideology has collapsed, and there is nothing to hold on to anymore. And I found that people talk too much, and write too much and say nothing.

> It's not just silence per se. It's silence in a large philosophical sense. Instead of going outward, you go inside and you look at the mirror inside yourself.[10]

Yunkers's ability to see the "mirror" inside himself is what, in fact, enabled him to remain innovative and to be true to himself throughout his life—from the time he decided to become an artist at the age of fourteen. It allowed him to live through and be involved in numerous political, intellectual, and artistic movements and yet have them serve only as backdrops to his unique life and career. Yunkers's one constant was his commitment to his own creative character, which compelled him, when he was making his works, to reach again into the depths of silence inside and find the seeds for a new "garden," ready to grow.[11]

III

Notes

Introduction

1. Quoted in Jerry Tallmer, "Portrait of an Artist with No Strings Attached," *New York Post*, January 30, 1982, 12.

2. Interview with Nina Yunkers, May 1999.

3. After leaving for Berlin late in 1919, Yunkers maintained loose contacts with his parents and siblings. His sister, Pauline, came to the U.S. from a German displaced persons camp in April 1951. The brother and sister had not seen each other for thirty-two years. A reporter for the *Evening Gazette* in Worcester, Massachusetts, where Pauline first settled, wrote that the siblings had "language difficulties." Adja Yunkers explained: "When I lived in Latvia, it was forbidden to speak Latvian by order of the Russian czar. My sister learned it after the revolution in 1918. We had to do all our conversing in Russian or German"; Sidney B. McKeen, "City Woman Greets Artist Brother," *Worcester Evening Gazette*, December 1, 1951. Yunkers's brother, Bruno, also came to the U.S., benefiting from the same displaced persons program, in the winter of 1950. His father, Karl Kasper Junkers, died in Eslinger, Germany, in 1950. His mother, Adelina Federika Junkers, came to the U.S. in the 1950s and died in Cleveland, Ohio, in 1970.

4. For a discussion of the Abstract Expressionists' failure to constitute an avant-garde, see Michael Leja, "The Formation of an Avant-Garde in New York," in Michael Auping, ed., *Abstract Expressionism: The Critical Developments* (New York: Harry N. Abrams; Buffalo: Albright-Knox Art Gallery, 1987). Leja writes (p. 23): "During the 1940s, the New York School artists struggled to devise a version of modernist artistic practice that accommodated the new notions of human nature and mind being forged throughout the culture. Only on this highly abstract and broad basis can they legitimately be said to have shared a project.... The project was such that it allowed for considerable differences, not only in terms of style but also in terms of ideas addressed, beliefs mobilized, and priorities established."

5. Anonymous interview with Yunkers, 1968, 20. Courtesy of the Archives of American Art, Smithsonian Institution, Washington, D.C.

6. Andrew Forge, "Adja Yunkers," *Art International* 22 (January 1979): 36.

7. This book takes as a departure point a premise that individual expressions should be considered before their assessment as collective experience. As Michael Leja states in "The Formation of an Avant-Garde in New York" (p. 13), quoting Michel Foucault: "We must question these ready-made syntheses, the groupings that we normally accept before any examination, these links whose validity is recognized from the outset; we must oust those forms and obscure forces by which we usually link the discourse of one man with that of another, they must be driven out from the darkness in which they reign. And instead of according them unqualified, spontaneous value, we must accept, in the name of methodological rigour, that, in the first instance, they concern only a population of dispersed events." (Leja quotes Foucault from *The Archeology of Knowledge*, trans. A. M. Sheridan Smith [New York: Pantheon, 1972], 22.)

Having Foucault's words in mind, I decided for this book to make Yunkers's voice heard at length, extensively quoting from his own writings and including a selection of his writings at the end of the book.

Chapter 1
Early Wanderings

1. Matta, interview with Nancy Miller, Brandeis University, 1982, quoted in *Matta*, exh. cat. (Paris: Centre Georges Pompidou, 1985), 265: "I was born on 11/11/11, this is not really a true biography or the day when one is born, the place, the true story, these are the difficulties that one experiences identifying that which we call the world, those different me's, the others, the struggle to swim across those identities." All translations are by the author if not specified otherwise.

2. Quoted from a transcript of a talk given at the Corcoran Gallery of Art, Washington, D.C., on November 7, 1967, 1. The transcript was made available to me by the Brooklyn Museum of Art, New York. Hereafter cited as Corcoran Gallery talk. Some changes in style and punctuation have been made to clarify the English.

3. Yunker's birth certificate was issued in Sweden with the annotation: "Verified by the Latvian Legion in Stockholm, April 30, 1940." It was probably issued at Yunkers's demand in order to apply for Swedish citizenship. The Archives of American Art, Smithsonian Institution, Washington, D.C., made the document available to me.

The family name changed from "Junker" to "Junkers" after the Latvian government passed a law requiring Latvians to add an "s" to their family names to distinguish themselves nationally when the country regained its independence in 1919.

4. Corcoran Gallery talk, 2. Yunkers's years in Russia remain a mystery. For a discussion of various, confusing accounts, see William H. Robinson, "A Cloud in Pants, Adja Yunkers: Icons to Abstract Expressionism" (Ph.D. diss., Case Western Reserve University, Cleveland, 1988), chaps. 2 and 3.

5. Corcoran Gallery talk, 2.

6. For Gorky, see below, chapter 4, note 34.

7. Yunkers often credited Kandinsky for introducing him to abstract art. See, for example, Paul Cummings interview with Yunkers, 1969, 13. Transcript courtesy of the Archives of American Art, Smithsonian Institution, Washington, D.C.

8. Corcoran Gallery talk, 6.

9. Quoted in Tallmer, "Portrait of an Artist." Yunkers stated on many occasions that he met Malevich in Russia between 1914 and 1917, although there is no evidence that such a meeting took place. Explaining his enthusiasm for Russian avant-garde art, Yunkers said in the Corcoran Gallery talk: "I tried to convey to you the condition of the, as Kierkegard called it—*VITA ante acta*—of artists such as Tatlin, Malevich, El Lissitzky, the Burliuk brothers [David and Vladimir], Naum Gabo, and Antoine Pevsner and many others I could name—who never ceased to be artists no matter the circumstances, did not compromise and persisted in their efforts of creating new dimensions in perception" (Corcoran Gallery talk, 7).

10. Quoted in Irene Clurman, "Exploring the Visual Equivalent of Silence," *Rocky Mountain News* (Denver), April 21, 1983, 89 and 94.

11. Corcoran Gallery talk, 5.

12. Ibid., 3.

13. Malevich stressed the populist rather than the religious appeal of icons, connecting them to the "emotional life of the peasants, which I had loved earlier, but whose meaning I hadn't fully understood," and he admired icons for the emotional power they conveyed through color and form. Yunkers probably would have agreed with Malevich's statement: "My acquaintance with icon art convinced me that the point is not in the study of anatomy and perspective, that it's not in depicting nature in its own truth, but that it's in the sensing of art and artistic reality through emotions. In other words, I saw that reality or theme is something to be transformed into an ideal form arising from the depths of aesthetics. Therefore in art, anything can become beautiful. Anything not in itself beautiful, but realized on an artistic plane, becomes beautiful." Kazimir Malevich, "Artist's Autobiography, 1933" (fragments), quoted in *Kazimir Malevich*, exh. cat. (Amsterdam: Stedelijk Museum, 1989), 110–11.

14. Robinson, "Cloud in Pants," 13–14.

15. Corcoran Gallery talk, 10. Yunkers said that he left Petrograd in 1917 and wandered through Russia for the next several years. From Yunkers's and his sister's recollections, it has been established that the family spent the next two years moving around Russia before returning to Latvia in February 1919. Instead of Riga, they settled in Liepaja, then under the supervision of the British army. Adja and his father enlisted in the Latvian nationalist army to fight against the newly established Bolshevik government. After recovering from a leg wound, Yunkers left Latvia for Germany in the fall of 1919, determined to pursue a career as an artist.

16. Istvan Deak, *Weimar Germany's Left-Wing Intellectuals* (Berkeley: University of California Press, 1968), 14–15.

17. Corcoran Gallery talk, 10.

18. Ibid., 11.

19. The art historian and art collector Rosa Schapire wrote one of the earliest positive articles on Emil Nolde (in 1907) and the catalogue raisonné on Karl Schmidt-Rottluff.

20. Robinson, "Cloud in Pants," 40.

21. Yunkers was included in an exhibition of Russian art at the Galerie H. von Garvens in Hanover.

22. The work at the Hamburger Kunsthalle bears an inscription in German: "'Ich und die Nacht' Adja Junker. J20. Mich packt Grauen, Angst, Verzückung—Abscheu, ja Abscheu ist es. Dieser Abscheu ist auf meinen Sippen erbaut. Bin ich verrückt—oder werde ich es erst allmählich, jangsam, so wie man in Nirvana übergeht?" (*The Night and I*, Adja Yunker, 1920. I am seized by terror, fear, revulsion, loathing, yes, it's loathing. This loathing is built on my ancestors [clans]. Am I insane, or am I just becoming slowly insane as one [does] when going over into nirvana?)

23. Madlain Yunkers, the artist's daughter, dates the picture to 1925.

24. Madlain Yunkers confirms that her father called his first wife "Hillush" (interview with the author, February 1999).

25. Interview with the author, February 1999. She stated that her father told her that there was another son named Kurt born in Dresden in 1922, who died shortly after World War II. His mother's name was Sonia.

26. Ibid.

27. *Valori Plastici* was edited by the painter and critic Mario Broglio. Contributing authors included Gino Severini, Jean Cocteau, André Breton, Louis Aragon, and Kandinsky. Artists around *Valori Plastici*, who also included Giorgio de Chirico, formed a loose association and exhibited together in Berlin, Dresden, and Hanover in 1921 and in Florence in 1922. They propagated an art with solid "classical" foundations in opposition to the changing approach to art of the so-called avant-garde. Yunkers may have met Carrà and Zur Muenlen during one of the exhibitions in Germany. At that time he responded strongly to the artistic style and attitudes propagated by *Valori Plastici*, as is confirmed by his early works known from photographs.

28. Robinson, "Cloud in Pants," 46.

29. Corcoran Gallery talk, 15. Dore Ashton, in an interview with the author, March 1999, recalled that when she and Yunkers visited Spain in the late 1950s, Yunkers did not talk much about his earlier trip and seemed to be discovering many places for the first time.

30. Robinson, "Cloud in Pants," 47.

31. Quoting Yunkers, Robinson (ibid.) states that while traveling aboard the *Haderslev* the artist jumped ship at Le Havre and went to Paris.

32. Corcoran Gallery talk, 18.

33. Yunkers scrapbook, "Béni soit qui mal y pense" (subtitled "Poems, Dreams, and Memories"), n.p. All citations from Yunkers's scrapbooks are courtesy of the Museum of Modern Art Library, New York.

Yunkers kept a photograph of Klee from 1925, which he included in one of his scrapbooks. He stayed in touch with Grohmann after World War II and mentions him in a letter to Una E. Johnson, curator of prints and drawings at the Brooklyn Museum (letter from Rome, November 18, 1954, Yunkers file at the Brooklyn Museum of Art Library).

34. Yunkers wrote in his scrapbook: "I changed my name from Junker[s] to Yunkers because living in Spanish speaking countries J is pronounced as H—ergo—my name would then be pronounced Hunkers—which displeased me so it was that the Y would help me to pronounce my name correctly. And I kept it this way for the rest of my life."

35. Photographs courtesy of Madlain Yunkers.

36. Robinson, "Cloud in Pants," 77, identified the woodcut as made after an oil-on-canvas with the same composition and title (Nañigos, 1927, Jack Chrysler Collection). Robinson mentions that Lilly Nilsson, the artist's third wife, remembers the print being made in the late 1930s.

37. The photograph is in the archives of the Estate of Adja Yunkers.

38. The word lubok (plural lubki) may be derived from lub (bast), the raw material used instead of parchment, obtained from soft strips of wood, dried, and pressed into thin sheets and utilized for painting predominantly religious images.

39. Giulio V. Blank, "Cuban Modernism: The Search for a National Ethos," in Wifredo Lam and His Contemporaries, 1938–1952, ed. Maria R. Balderrama (New York: Harry N. Abrams and Studio Museum in Harlem, 1992), 57.

40. Letter originally published in Diario de la Marina (Havana) in 1927, quoted in Roberto Gonzalez Echevarria, Alejo Carpentier: The Pilgrim at Home (Ithaca: Cornell University Press, 1977), 68.

41. Manuscript of an interview with Carpentier by Aldo Menendez, courtesy of José Veigas.

42. Interview with Ashton, March 1999.

43. Yunkers wrote: "Dulce Maria Loynaz de Castillo. These poems were addressed to me in Havana Cuba during the years 1924–1927. A great beauty. A good poet. To get to her bedroom in a separate house one had to walk on a plank 10″ wide which rested on the branches of 2 trees—from the main room to her house and directly into the bedroom. Her chauffeur would drive us at midnight in her Mercedes convertible to some cemetery in the country where she would read her poems to me." Yunkers scrapbook, "Béni soit qui mal y pense," n.p.

44. Corcoran Gallery talk, 18.

45. Robinson's inteview with Yunkers (1983), quoted in "Cloud in Pants," 55.

46. Corcoran Gallery talk, 19.

Chapter 2
The First Woodcuts

1. Corcoran Gallery talk, 20. Yunkers had to stop his talk at this point; he probably ran out of time.

2. Cummings interview with Yunkers, 1969.

3. The article about Yunkers by Anja Brand appeared under the title "Un artiste proletarien: Adja M. Yunkers" in Monde, November 30, 1929, 7.

Monde, which was not related to Le Monde, was published between 1928 and 1933. Included on its advisory board were Albert Einstein, Maxim Gorky, and Upton Sinclair. As a cultural review representing "compagnons de route," it was sympathetic to social causes without being orthodox in its opinions. But Barbusse's independence led to criticism of Monde in La Révolution surréaliste and Le Surréalisme au service de la Révolution by both André Breton and Louis Aragon. Barbusse's independence also caused him public condemnation for "promot-ing the ideology hostile toward the proletariat" at the Second International Congress of Revolutionary Writers in Kharkov, Russia, in 1930. Barbusse has been described as belonging to the generation morale of Western European intellectuals who combined strong leftist convictions with humanism par excellence. For Barbusse, see Jean Relinger, Henri Barbusse: Ecrivain combattant (Paris: Presses Université de France, 1994).

4. Fernand Leriche, "Boris Taslitzky, peintre de la dignité humaine," Notre Musée 114 (April 1989): 2; courtesy of the City Hall, Ivry-sur-Seine, France.

5. Kasia Knap (a friend and artist who interviewed Taslitzky for me), telephone conversation with Boris Taslitzky, February 1999.

6. Cummings interview with Yunkers, 1969, 21. In an unpublished interview conducted by Aldo Menendez with Alejo Carpentier, Carpentier recalls that Yunkers's murals were in Bobigny (another Parisian suburb with a leftist government during the period) and that they were done around 1935. José Veigas made a copy of the manuscript, signed by Carpentier, available to me.

7. Chronologies compiled by David Acton (in Adja Yunkers: Paintings, Drawings, and Prints, 1940–1983, exh. cat. [New York: Associated American Artists, 1990]) and Edward B. Henning (in Adja Yunkers, exh. cat. [Salt Lake City: Utah Museum of Fine Arts, 1969]) both indicate that Yunkers returned to Germany briefly in 1927 and then settled in Paris in 1928. Anja Brand's article in Monde ("Un artiste proletarien") supports the assessment that Yunkers's prints were made in Germany. Brand mentions that she went to see Yunkers in Berlin in 1929.

8. Anarcho-Syndicalism, also called Syndicalism, or Revolutionary Syndicalism, was an international movement that advocated direct action by the working class to abolish capitalist order, including the state, and to establish in its place a social order based on workers' organizations. The Syndicalist move-

ment flourished in France between 1900 and 1914, later spreading all over Europe and Latin America. See *The New Encyclopaedia Britannica*, 15th ed., s.v. "Syndicalism."

9. The images of Mickey Mouse in Madlain Yunkers's room in Hamburg witness the homogenization of culture that hit Europe in the 1930s. The critic Serge Fauchereau observed: "When they are not *engagés* (the ancient *Pierrot* and *Lisette* of the Catholic inspiration and more recently *My camarade*, Communist) they are based on the American model of the *Journal of Mickey* appearing in France in 1934, then in Great Britain, in Spain, in Portugal; giving birth to *Robinson Junior* (1936), *Hardi* (1937), and, in Belgium, *Spirou* (1938)"; quoted in *Année 30 en Europe, le temps menaçant*, exh. cat. (Paris: Flammarion and Paris Musées, 1997), 374.

10. Pontus Hulten, "Little History and Explanation," in *Sleeping Beauty— Art Now, Scandinavia Today*, exh. cat. (New York: Solomon R. Guggenheim Museum, 1982), 13.

11. Yunkers mentioned this in the Cummings interview, 23–24. He also stated that some of the *Ten Commandments* prints were published in *L'Humanité*.

12. Interview with Ashton, March 1999.

13. Herschel B. Chipp, *Picasso's Guernica: History, Transformations, Meanings* (Berkeley: University of California Press, 1988), 54.

14. Yunkers's biographical information about his private life in Sweden was provided to Madlain Yunkers by Lilly Nilsson in a letter dated August 22, 1984. Courtesy of Madlain Yunkers.

15. Information obtained from Lilly Nilsson by William Robinson, in his "Cloud in Pants," 67–68.

16. The Halmstad group was a Swedish arts organization formed in 1929. Initially influenced by Cubism and Neo-plasticism, artists in the group moved toward Surrealism during the 1930s.

17. In the first issue of *Ars* magazine, Yunkers included his drawing *The Shoemaker*, which served as the prototype for his woodcut of the same title.

18. Article preserved in one of Yunkers's scrapbooks, n.p.

19. Yunkers scrapbook, "I am not here anymore," 1982, n.p.

20. Giorgio de Chirico, "Meditations of a Painter," 1912, in Herschel B. Chipp, *Theories of Modern Art: A Source Book of Artists and Critics* (Los Angeles: University of California Press, 1984), 398.

21. Breton's *Giorgio de Chirico*, quoted in Jack J. Spector, *Surrealist Art and Writing, 1919–1939: The Gold of Time* (Cambridge: Cambridge University Press, 1997), 154.

22. Una E. Johnson, *Adja Yunkers: Prints, 1927–1967* (New York: Brooklyn Museum, 1969), 13.

23. Richard Mortensen, "Adja Yunkers," in *Adja Yunkers, Grafik* (Copenhagen: Tokantens Kunsthandel, 1947), n.p. The exhibition toured the Scandinavian cities of Oslo and Stockholm.

24. Johnson, *Adja Yunkers*, 12.

25. Cummings interview with Yunkers, 1969, 39–40

26. In early 1941 he had a show of his Surrealist paintings at the Pottinger Gallery in Pasadena, California. A review in the *Pasadena Star News* from January 18, 1941, said that the exhibition included twenty-five of Yunkers's paintings brought to the U.S. by "an English friend." It also mentioned that Yunkers used "automobile paint" (probably some sort of industrial paint) and that "in two of these pictures you will find two decorative paper doilies glued to the canvas."

27. On January 24, 1947, a special issue of *AT* (the official newspaper of the Social-Democrats) reported on the front page, "Famous Artist Woke Up in a Dramatic Fire in Stockholm." Several other Swedish newspapers wrote about the fire and published photographs of Yunkers and his wife. Yunkers preserved these articles in the scrapbook "Béni soit qui mal y pense."

Chapter 3
Printmaker in America

1. Cummings interview with Yunkers, 1969, 45.

2. Yunkers's Guggenheim application for 1949–50 courtesy of the John Simon Guggenheim Memorial Foundation.

3. Josephine Gibbs, "Swedish Modern," *Art Digest*, November 15, 1946, 16.

4. Yunkers's Guggenheim application, n.p.

5. Quoted in *Albuquerque '50s*, exh. cat. (Albuquerque: University of New Mexico Art Museum, 1989), 25.

6. Malin Wilson, "The Albuquerque School," in *Albuquerque '50s*, 12–13.

7. Ibid., 41–42.

8. As stated in the first issue of the portfolio, *Prints in the Desert* was intended to be published four times a year.

9. Wilson, "Albuquerque School," 42.

10. John Palmer Leeper, "Adja Yunkers," *New Mexico Quarterly* 20 (Summer 1950): 191–95.

11. Yunkers scrapbook, "Béni soit qui mal y pense," n.p. Yunkers continues: "Some time in the mid fifties, I think, Dore [Ashton] and I were in Paris and somehow Dore got to know Mr. George Salle, the director of the Louvre, who invited us one Sunday for lunch in his rooms in the Louvre. To get to his apt. he had to use half a dozen keys, large & small, gates and doors, alarm bells, etc. etc.... At any rate, during lunch I pointed out to Mr. Salle the fact of the hidden Pietà with the result that from that day on the Pietà now hangs beautifully displayed, as it deserves." *Pietà d'Avignon* in the Louvre has attracted a great amount of attention from other artists; for example, the Canadian painter Paul-Emile Borduas admired it in 1928, and the French artist Nicolas de Stael paid special attention to it when he visited the Louvre in 1947.

12. Yunkers's portfolio of five prints, with an essay by Leeper, was one of three portfolios issued under the auspices of Rio Grande Graphics. The

other two were devoted to prints by Gabor Peterdi and Seong Moy, respectively. The portfolios were published by Ted Gotthelf and edited by Dore Ashton, who then worked as print editor for *Art Digest*. See Clinton Adams, introduction to *Adja Yunkers: Woodcuts, 1927–1966*, exh. cat. (New York: Associated American Artists, 1988).

13. Johnson, *Adja Yunkers*, 17.

14. Photographs of the ceiling collapse are preserved in the scrapbook "Béni soit qui mal y pense," accompanied by the text: "First crash of ceiling 1953 at a walk-up flat on E [East] 34 St. More were to happen but I didn't know then. I just worked late to finish several editions of a polyptych—5 panels—14 feet long woodcuts, the center panel had 36 colors. They were to be shown at the Borgenicht Gallery NYC. The ceiling fell at 1 am nearly missing to kill us—Dore and me."

15. Yunkers's Guggenheim application for 1953–54 courtesy of the John Simon Guggenheim Memorial Foundation.

16. Press release, Grace Borgenicht Gallery, New York, May 1953.

17. *Art and Architecture*, July 1953, 11, 32.

18. Adelyn D. Breeskin, "Adja Yunkers—Pioneer of the Contemporary Color Woodcut," *Baltimore Museum of Art News* 16 (June 1953): 7.

19. The letter is stamped "Received Nov 17, 1954." Courtesy of the John Simon Guggenheim Memorial Foundation. During his stay in Europe, Yunkers had shows at Studio Paul Facchetti in Paris, the Galeria Schneider in Rome, the Galleria Numero Redazione in Florence, the Zwemmer Gallery in London, the Galerie d'Art Moderne in Basel, and the Götesborgs Konstmuseum in Sweden. He also participated in a number of group exhibitions, including the *Il Gesto* exhibition at the Galleria Schettini in Milan, which in August 1957 traveled to the Instituto de Arte Contemporaneo in Lima, Peru.

20. Will Grohmann, foreword to *Yunkers: Color Woodcuts and Monotypes*, exh. cat. (New York: Grace Borgenicht Gallery, 1955), n.p.

21. The curators who selected Yunkers were Adelyn D. Breeskin (Baltimore Museum of Art), Gustave von Groschwitz (Cincinnati Art Museum), Elizabeth Mongan (National Gallery of Art, Washington, D.C.), Heinrich Schwarz (Davison Art Center, Wesleyan University), and Carl Zigrosser (Philadelphia Museum of Art).

22. Cummings interview with Yunkers, 1969, 39–40.

Chapter 4
European Artist in New York

1. Jean-Paul Sartre, "New York, the Colonial City," 1946, in Jean-Paul Sartre, *Literary and Philosophical Essays*, trans. Annette Michelson (New York: Collier Books, 1967), 129.

2. *Decalcomania* is a term used by the Surrealist Oscar Dominguez around 1935 for a monotype technique in which paint is applied to smooth paper, then another sheet is applied to it with pressure and immediately peeled off. Yunkers experimented with *decalcomania* in the early 1940s, as witnessed by an untitled work inscribed "Stockholm 1942" (Estate of Adja Yunkers). Other Surrealist artists used the technique with canvas or glass rather than paper. See René Passeron, *The Concise Encyclopedia of Surrealism* (Secaucus, N.J.: Chartwell Books, 1975), 259.

3. Anonymous interview with Yunkers, 1968, 7.

4. Cummings interview with Yunkers, 1969, 46.

5. Ibid., 48.

6. Ibid., 37–38.

7. These works are in various collections; some are known to me only from photographs in the Estate of Adja Yunkers. *Composition III*, dated November 7, 1956, was later retitled and redated *Hot and Cold*, 1957 (private collection, New York).

8. Thomas B. Hess on Rothko in "Mixed Pickings from Ten Fat Years," *Art News* 54 (Summer 1955): 36–39, 77–78.

9. The sexual connotations of *Composition in Black and Ocher* become apparent when the work is compared with a woodcut, *Composition N–1957*, made around the same time, which looks like a gigantic phallus.

10. Yunkers scrapbook, "Béni soit qui mal y pense," n.p.

11. Dore Ashton, introduction to *Antonio Saura, reperes*, exh. cat. (Paris: Galerie Lelong, 1997), 15.

12. Telephone conversation with Dore Ashton, January 1999.

13. William Jay Smith, *The Skies of Venice*, exh. cat. (New York: André Emmerich Gallery, 1961).

14. Yunkers's pastels received favorable reviews from, among others, *Art International*, the *New York Times*, *New York Post*, *Art News*, and *Arts Magazine*. Critic Martica Sawin, in one of her numerous articles on Yunkers, praised him highly, while providing a clear description of Yunkers's working process and the impact of his pastels on the viewer: "The method of rubbing on the pastel and fixing it in many layers, produces a wonderful luminosity, of resplendent color made vibrant by the layers of dark and light which flicker beneath it as an all-over melting or dissolving effect which keeps the work in its constant state of flux. These works represent a culmination in Yunkers' career in that they display the fullest realization of the artist's inherent powers—on the one hand, as a virtuoso technician and innovator, and on the other, as a man who needs to expend to the fullest his passion for intelligence in art." Martica Sawin, "Adja Yunkers," *Arts Magazine* 34 (November 1959): 58.

In 1958 the Worcester Art Museum mounted a show titled *Some Younger Names in American Painting* that aimed at introducing a group of artists, half of them with clearly foreign names: José Guerrero, Kenzo Okada, and Adja Yunkers. Yunkers was included with Richard Diebenkorn, David Park, and

Larry Rivers in *New Directions in Painting*, a 1959 exhibition that toured museums and university galleries in Florida. Yunkers's color pastels *Bewitcher's Sabbath*, 1958, and *Sestina I*, 1959, were selected for the show.

15. Edward B. Henning, *Fifty Years of Modern Art, 1916–1966* (Cleveland: Cleveland Museum of Art, 1966), n.p. *Sestina II* was titled after a lyrical fixed form distinguished by its six six-line stanzas invented by Arnault Daniel, a Provençal poet of the twelfth century, that was used by Dante and Petrarch. Yunkers's *Sestina* paintings may have been inspired by Ronald Britton's poem "Sestina—Ritornello." Yunkers preserved a sheet of paper with the typed poem in one of his scrapbooks and wrote next to it "Ronald Britton, Attaché to Sweden." The poem begins:

Dogs and homunculi promenade in sunshine,
Giants laze out siestas in the shadow;
Evening subtends the dominance of towers
And seals the subterranean life in trenches.
Above stretch antithetic flights of eagles
Resolving in the prophecy of music . . .

16. Yunkers scrapbook, "Béni soit qui mal y pense," n.p. In his letter Guston apologized for not writing to Yunkers and mentioned his poor health as the reason for remaining silent. Guston experienced a resurgence of popularity toward the end of his life, whereas Yunkers's popularity faded almost completely.

17. Statement in *It Is*, no. 4 (Fall 1959): 28.

18. The couple shared an admiration for the Dutch master. Ashton's interest in Rembrandt can be traced to her graduate studies at Harvard University, where she took courses with Jakob Rosenberg, a world-renowned Rembrandt specialist, who knew Yunkers's works and encouraged Ashton to write her thesis on color woodcuts.

19. Quoted in Ann Gibson, "The Rhetoric of Abstract Expressionism," in Auping, *Abstract Expressionism*, 86 (originally quoted in Selden Rodman, *Conversations with Artists*, 82).

20. Saint-John Perse, *Eloges and Other Poems* (New York: W. W. Norton, 1944), 25.

21. Quoted from Thomas B. Hess, "Prints: Where History, Style and Money Meet," *Art News* 70 (January 1972): 29, in Clinton Adams, *American Lithographers, 1900–1960: The Artists and Their Printers* (Albuquerque: University of New Mexico Press, 1983), 160.

22. "Tamarind Impressions: Lithographs from the Tamarind Workshop" (brochure), front page. The pamphlet contained a photograph of Yunkers working with the printer Bohuslav Horak.

During the initial period of Ford Foundation support, between July 1960 and June 1961, Tamarind fellowships were awarded to eight artists: Glen Alps, Louis Bunce, Jules Engel, Reuben Kadish, Tetsuo Ochikubo, Aubrey Schwartz, Romas Viesulas, and Yunkers.

23. Cummings interview with Yunkers, 1969, 34.

24. Letter to Una E. Johnson, January 3, 1961; courtesy of the Brooklyn Museum of Art Library.

25. In "Béni soit qui mal y pense," Yunkers noted: "As a small child I was afraid to go to bed because as soon as I would fall asleep closing my eyes I would see a tiny red pinpoint in a corner opposite my bed—this tiny red point would grow and as it grew it would fill the corner and expand into the room; as it grew bigger and bigger and acquiring a menacing appearance it would begin to roll toward my bed—swallowing me with its red heat—filling the whole room. I would then 'awaken' and screaming with fear run out into the hall where there was no one and hiding there against the wall I sometimes would spend the rest of the night."

26. Library, San Francisco Museum of Modern Art. The title *Salt* also may

refer to the title of an unorthodox art magazine Ashton planned to publish; the magazine never materialized (interview with Ashton, March 1999). It is also possible that Yunkers, who enjoyed verbal puns, chose the name as a misnomer, for he used the sugar-lift technique for his lithographs.

27. Cummings interview with Yunkers, 1969, 34.

28. Stephanie Terenzio, ed., *The Collected Writings of Robert Motherwell* (Oxford: Oxford University Press, 1992), 111.

29. Yunkers's postcard to Motherwell, dated May 22, 1963, courtesy of the Dedalus Foundation, which was established by Motherwell.

30. "We cannot love anything except in relation to ourselves, and we do not do anything except to follow our taste and our passion when we put our friends over ourselves; nevertheless, it is by this preference alone that friendship can be true and perfect." Letter dated February 8, 1963; courtesy of the Dedalus Foundation.

31. In the early 1960s Yunkers made several other three-dimensional works, among them a series of box pieces with melted black-glass elements in the middle, each inlaid with purple velvet and covered with Plexiglas (the glass was recovered from the site of a fire). These experimental works, which were given as gifts to various friends, were titled *Saudades* ("greetings" in Portuguese). Yunkers's interest in making sculptural works was only momentary, and he soon returned to painting.

32. Interview with Ashton, March 1999.

33. De Kooning once said, "Style is a fraud . . . you are with a group or movement because you can't help it." Quoted by Donald Kuspit in "Arshile Gorky: Images in Support of the Invented Self," from Jorn Markert, "Stylelessness as Principle: The Painting of Willem de Kooning," in *Willem de Kooning: Drawings, Paintings, Sculpture*, exh. cat. (New York: Whitney Museum of American Art, 1984), 127.

Arshile Gorky, *Garden in Sochi*, 1943, oil on canvas, 31 × 39 inches. Museum of Modern Art, New York.

34. Yunkers scrapbook, "Béni soit qui mal y pense," n.p.

Yunkers's metamorphosis after moving to America is similar to that of Arshile Gorky, who changed his name from the Armenian Vosdanik Manuk Adoian to the Russian one, after the writer Maxim Gorky (itself a pseudonym). Gorky's short career ended with suicide in 1948, but his legend outlived him and served as a source of inspiration for many artists. Yunkers could easily be one of them. Both men not only came from countries under Russian rule but also had a similar physique and temperament; tall and emotional, they were larger-than-life personalities who generated conflicting feelings in people around them. Yunkers's *My Childhood Garden on Vassilevsky Ostrov*, 1976–78, with a reference similar to Gorky's *Garden of Wish Fulfillment*, illustrated in his *Garden in Sochi* series, is a palimpsest referring to fragile memories of a mythical place while embracing a mythical idea of art. Gorky placed his childhood garden in a resort on the Black Sea; Yunkers transported his from Riga to an island in the center of Petrograd.

Gorky often made up his own history about himself, as would Yunkers later (see chapter 1). Gorky claimed that he had studied at the Académie Julien in Paris under Jean Paul Laurens and with Kandinsky before he came to America. See James M. Jordan and Robert Goldwater, *The Painting of Arshile Gorky: A Critical Catalogue* (New York: New York University Press, 1982), 19, and Diane Waldman, *Arshile Gorky, 1904–1948: A Retrospective*, exh. cat. (New York: Harry N. Abrams and Solomon R. Guggenheim Museum, 1981), 258.

35. The *Messenger* series is known to me through photographs made available by the Estate of Adja Yunkers.

36. Cummings interview with Yunkers, 1969, 17.

37. Yunkers's pastels were earlier presented in solo exhibitions in New York at Rose Fried (1957) and André Emmerich (1959). They were also included in, among other exhibitions, *Adja Yunkers: Recent Paintings* at the Baltimore Museum of Art (1960) and *American Abstract Expressionists and Imagists* at the Solomon R. Guggenheim Museum in New York (1961). Yunkers joined the influential André Emmerich Gallery in 1957 and officially stayed with the gallery until 1965.

38. Edward B. Henning, "Essay: Adja Yunkers," in *Adja Yunkers*, exh. cat. (Salt Lake City: Utah Museum of Fine Arts, 1969).

39. Cummings interview with Yunkers, 1969, 37–38.

40. When in 1966 curator Peter Selz put together the exhibition *Seven Decades 1895–1965: Crosscurrents in Modern Art*, organized to benefit the Public Education Association, which grouped artists by their associations with major New York galleries, the section devoted to André Emmerich did not include Yunkers. Yunkers was mentioned among artists associated with Cordier and Ekstrom, and his work (*Entwined Flame*, 1959) was reproduced on the same page with works by Jean Dubuffet, Guston, and Richard Pousette-Dart. See Peter Selz, *Seven Decades 1895–1965: Crosscurrents in Modern Art*, exh. cat. (New York: Public Education Association, 1966).

41. *Art Voices* 1 (December 1962): 17.

42. Brian O'Doherty, "Art: Adja Yunkers Show," *New York Times*, November 23, 1962, 59.

43. Georgine Oeri, "Adja Yunkers, or the State of 'Irritable Richness,'" *Art International* 5 (November 1961): 37.

44. Bernard Rosenberg and Norris Fliegel, *The Vanguard Artists: Portrait and Self-Portrait* (1965; New York: Arno Press, 1979), 230.

45. *American Prints Today/1962*, exh. cat. (New York: Print Council of America, 1962), 71.

Chapter 5
The Community of Artists and Poets

1. Octavio Paz, "Review in the Form of a Parable," in *Essays on Mexican Art*, trans. Helen Lane (New York: Harcourt Brace, 1993), 21.

2. Gaston Bachelard, *The Poetics of Space*, trans. Maria Jolas (Boston: Beacon Press, 1964), 64.

3. Their daughter was given three first names: Sasha, Alexandra, Louise. Interview with Ashton, March 1999.

4. Cummings interview with Yunkers, 1969, 36.

5. The works are known to me from the exhibition catalogue from Darmstadt: *Internationale der Zeichnung*, exh. cat. (Darmstadt: Stadt Darmstadt, 1964).

6. Other artists included Jean Charlot, Robert Marx, Fred Conway, Anton Refregier, Kenneth Callahan, and Marion Greenwood.

7. "Adja Yunkers' New Mural on the Campus of Syracuse University," press release, Syracuse University; courtesy of Syracuse University.

8. Ibid., 3.

9. Ibid., 3–4.

10. All Syracuse letters are courtesy of Dore Ashton.

11. Online at http://sumweb.syr.edu/suart/campus1.htm.

12. Lucy Lippard, "Hot Potatoes: Art and Politics in 1980," in *Re-visions: New Perspectives of Art Criticism*, ed. Howard Smagula (Englewood Cliffs, N.J.: Prentice-Hall, 1991), 37; originally printed in *Block* 4 (1981).

13. John Graham, *System and Dialectics of Art*, ed. Marcia Epstein Allentuck (Baltimore: Johns Hopkins University Press, 1971), 115–16. Graham was another of the artists and critics from Russia who changed their names (and reinvented themselves) after moving to the United States. He came to America in 1920.

14. By calling his new series of paintings *Aegeans*, Yunkers made a reference to the Greek islands and sea. When asked about the title, however, the artist rejected any connections of his work to his experiences in Greece. Yunkers and Ashton visited Greece in the late 1950s and spent the summer in Hydra as guests of the local Academy of Fine Arts. Both remembered the trip as a dreadful experience, whereas Yunkers's collage paintings generate a sense of peace and harmony. Once again, what Yunkers brought to his art from his travel was not a psychic presence of a specific place but rather a reverie of such a presence translated into an aesthetic experience.

15. Anonymous interview with Yunkers, 1968, 14.

16. Harold Rosenberg, "The Philosophy of Put-Togethers," *New Yorker*, March 11, 1972, 117.

17. Henning, "Essay: Adja Yunkers," n.p.

18. Yunkers scrapbook, "I am not here anymore," n.p.

19. Paz traveled to Spain and France in 1937, but Ashton doubts whether Yunkers met him in Paris during that time; interview with Ashton, March 1999.

20. Peter A. Wick, "Gallery Reviews: Adja Yunkers: Phoenix in Boston," *New Boston Review* 1 (Winter 1975): 27.

21. Cummings interview with Yunkers, 1969, 41–42.

22. The poem "Blanco" was first published in Mexico in 1967. It was translated into English by Eliot Weinberger.

23. Quoted from the portfolio *Blanco*; courtesy of the Estate of Adja Yunkers.

24. Ibid.

25. Quoted from the portfolio *Poems for Marie José*; courtesy of the Estate of Adja Yunkers.

26. In the early 1980s Yunkers wrote five large pages of quotations about books, which began with Plato's "Books are immortal sons deifying their sires" and ended with a quote from Hermann Zapf's *Homage to the Book:* "In this electronic future, the responsibility of the book designer will be even heavier. No longer will he be an unnecessary cost factor; he will direct the whole orchestra in which any false note means additional cost and loss of time." The pages are in the Adja Yunkers Estate.

27. Kathleen Raine was among Yunkers's English friends from before World War II. In a scrapbook ("I am not here anymore," n.p.) Yunkers preserved a letter from her dated March 31, 1938, which contains a typed poem titled "Easter Poem" and a handwritten inscription "Grâce à vous, Adja." The enigmatic inscription suggests that Yunkers may have inspired Raine to write the poem. It reads:

> The spring shall rouse my buried Lord
> See him evacuate the loam,
> Oh man, oh man, how thin you've grown
>
> The sun shall summon up his own,
> His gown is white, his skin is brown,
> But man, oh man, how thin you've grown.
>
> Did you suffer life in vain?
> Your lips are sealed, your mind is gone,
> Oh man, oh man, how thin you've grown.
>
> Rivers have washed away his brain,
> His bones are rock, he feels no pain,
> But man, oh Lord, how thin you've grown.

Raine crossed out "death" and replaced it with "life." She copied by hand her poem "Tiger Dream" on the other side of the sheet of paper.

28. See photograph of Yunkers's studio, Archives of American Art, Smithsonian Institution, Washington, D.C.

29. Paz, "Invitation of Space," 39.

30. Forge, "Adja Yunkers," 36–37.

Chapter 6
Reaching for Silence

1. Yunkers, quoting Jean-Marie Domenach, "Malraux and Death," *New York Review of Books*, December 8,

1977. In one of Yunkers's scrapbooks, n.p.

2. Yunkers's archives contain pictures of blood cells clipped from newspapers and magazines. Courtesy of the Estate of Adja Yunkers.

3. Clurman, "Exploring the Visual Equivalent of Silence." Yunkers's technique of pasting a piece of canvas to a larger canvas that can only be seen up close echoes Rothko's floating rectangles, which, on their part, recall Malevich's white-on-white Suprematist paintings. Malevich, however, looked for a dynamic quality in his compositions by tilting geometric figures and suspending them in the white field (a cipher of the cosmos) and establishing a figure-ground opposition. Yunkers preferred to have his rectangles integrated into the painting by taking over almost the entire surface and invisibly merging with the background, or delineating irregular geometric shapes with sinusoidal lines and aligning one or two edges with the edges of the painting. Modernists per se, Malevich and Yunkers perceived icons as expressions of specific, semicryptic language, with the peculiarities of their painting techniques providing explanation of their iconographic contents. Harold Rosenberg's description of Barnett Newman's paintings as icons because "they request the viewer's faith—they can exist as art only if his audience believes they are art" applies equally to the work of Adja Yunkers. See Ann Gibson, "The Rhetoric of Abstract Expressionism," in Auping, *Abstract Expressionism*, 75; Gibson paraphrases Rosenberg from his "Icon Maker: Barnett Newman," in *The Redefinition of Art* (New York: Collier Books, 1972), 96–97.

4. Quoted in Tallmer, "Portrait of an Artist."

5. Both photographs courtesy of the Estate of Adja Yunkers.

6. Marsha Miro, "He's 75, But His Work and Spirit Are Fresh," *Detroit Free Press*, April 4, 1976, 4C.

7. Yunkers reported this to his daughter Madlain in a letter dated November 17, 1978; courtesy of Madlain Yunkers. The telegram is preserved in one of Yunkers's scrapbooks.

8. Quoted in Tallmer, "Portrait of an Artist."

9. Courtesy of the Estate of Adja Yunkers.

10. Clurman, "Exploring the Visual Equivalent of Silence."

11. An unsigned obituary in the *New York Times* from December 28, 1983, titled "Adja Yunkers, Artist: Explored Uses of Color," stated: "Adja Yunkers, a Latvian-born American artist known for his abstract paintings, prints and pastels, died Saturday at the New York Infirmary—Beekman Downtown Hospital. He was 83 years old. Mr. Yunkers used soft, lyrical colors, balanced to interact with each other and activate the entire pictorial surface."

In 1984 Yunkers had a posthumous retrospective at the Fine Arts Museum of Long Island, for which he had begun preparing the previous year.

Chronology

Rachel Evans

1900

On July 15 Adolf Eduard Vilhelm Junker was born in Riga, a thriving industrial city in Latvia. His more familiar nickname, "Adja," was a Latvian derivative of Adolf. His parents were German-speaking Latvians: Karl (Karlis) Kasper Junker (1876–1950), an industrial mechanic, and Adelina Federika Junker, née Stahl (1880–1970). (His parents later changed their name to Junkers.) Yunkers was the oldest of three children; his sister Pauline was born in 1902 and his brother Bruno in 1905.

1914

Germany declared war on Russia. Yunkers left home for Petrograd (now St. Petersburg), where he was introduced to the artistic ferment of pre-Revolutionary Russia.

1916

Yunkers enrolled in art school in Petrograd, at either the Higher School of Art, or, more possibly, the Drawing School of the Society for the Encouragement of the Arts in Petrograd, which offered evening drawing classes.

1919–20

Yunkers moved to Berlin for one month, then settled in Hamburg. He created his earliest known paintings: watercolors on wrapping paper for sandwiches.

1921

Yunkers was given his first solo exhibition, at the Maria Kunde Galerie in Hamburg. He used the earnings to rent a studio and make several trips to Berlin, where he met members of the Sturmgruppe, including Karl Schmidt-Rottluff and Emil Nolde. Later this year Yunkers participated in a large Russian art exhibition at Galerie H. von Garvens in Hanover with avant-garde artists Wassily Kandinsky, Alexander Archipenko, and Marc Chagall.

1922

Expelled from Hamburg by authorities, Yunkers traveled to Florence, where he met Carlo Carrà and Herminia Zur Muenlen, artists associated with *Valori Plastici* magazine.

1923

Yunkers returned to Germany briefly, then departed for Spain in October. He traveled through Spain, sleeping in flophouses and drawing small portraits for money, and finally landed on Las Palmas, in the Canary Islands.

1924

Continuing his travels, Yunkers became a stoker on the Danish freighter *Haderslev* for three months, sailing to Africa and returning to Las Palmas in March. He then spent several months in Paris studying paintings at the Louvre. During this year he also traveled to Dresden.

1925

Yunkers married Hildegard Kutnewsky in Hamburg on April 9, but soon returned to France without his wife.

1926

In January Yunkers arrived in Havana, Cuba, and changed his name from Junkers to Yunkers. While in Cuba he worked as a commercial artist and designer for the department store La Casa Grande and published two underground leftist papers, one of which was banned for its radical views. The writer and music critic Alejo Carpentier and the symbolist poet Dulce Maria Loynaz were among his friends in Cuba.

Yunkers in Petrograd, ca. 1914. Estate of Adja Yunkers.

Yunkers and Hildegard Kutnewsky-Junkers in Cuba, June 1926. Photograph courtesy of Madlain Yunkers.

Yunkers in Paris, ca. 1928.
Photograph courtesy of Madlain
Yunkers.

Yunkers in his studio in Sweden.
Photograph courtesy of Madlain
Yunkers.

Cover of *Skies of Venice* series
of prints, 1960.

1927

Cuban President Gerardo Machado
began persecuting leftists, and Yunkers
fled the island. He went to Mexico, where
he met Diego Rivera, then he returned to
Germany. In late fall, after a brief visit
to Hamburg, Yunkers settled in Berlin.

1928

Yunkers worked in Berlin painting
fresco murals on public buildings. He
divorced Kutnewsky-Yunkers.

1930–32

Yunkers left Berlin in fear of the Nazi
regime and moved to Paris, where he
lived with a woman named Anna
in a hotel at Avenue de Maine. In Paris
Yunkers met Henri Barbusse, editor
of *Monde*. Barbusse may have helped
Yunkers acquire a commission to paint
large murals for the City Hall in Ivry--
sur-Seine, a Paris suburb. (Also see
Chapter 2, note 6.) During this period
he produced his woodcut series *The Ten
Commandments*.

1933

Yunkers returned to Hamburg for the
last time in January, trying to convince
Hildegard to leave Germany due to the
danger of war, but his efforts failed.
Hildegard finally fled Hamburg with her
daughter and went to Barcelona, Spain,
in 1934.

In May Yunkers immigrated to Sweden,
where he was already well known
through the political woodcuts and
murals he had made in Paris and
Germany. The Swedish Anarcho--
Syndicalists received him graciously
in Stockholm, and he became a member
of their party.

In November Yunkers married his
second wife, a Swedish woman named
Märta Fernström.

1935

Fernström gave birth to Yunkers's only
son, Mikael Bjornstjarna, the only child
of their marriage.

1936

Yunkers visited Barcelona, and upon
his return to Sweden he divorced Märta.
In September Yunkers married his third
wife, the well-known Swedish journalist
and singer Lilly (Lil) Nilsson. Yunkers
slowly dissociated himself from the
Anarcho-Syndicalists, at Lil's request,
and began to associate with Surrealist
and Symbolist poets.

1939

World War II began, but Sweden
remained neutral. Yunkers visited
Norway and Denmark and began to
make color woodcuts. The next sixteen
years would be a period of intense
printmaking for the artist.

1941

Yunkers had his first exhibition at
Pottinger Gallery in Pasadena,
California, though he did not attend it.

1942–45

In Stockholm, Yunkers edited and pub-
lished the Surrealist art journal *Création*,
printed by hand on newsprint, the maga-
zine *Ars*, and *Ars-portfolios*, a collection
of original prints issued in editions of
five hundred. Yunkers's *Hommage à la
Suède* created a stir at the first exhibition,
in 1943, of the Swedish Surrealist group
Minataur Gruppen, in Malmö. In 1944,
Nilsson and Yunkers filed for divorce.
Yunkers began to exhibit widely and
became known internationally as a
graphic artist.

1946

Yunkers married his fourth wife,
Kerstin Bergstrom. The Louis Hahne
Konsthandel in Stockholm held a
large exhibition of Yunkers's prints.
Bergstrom traveled to the United States,
where Yunkers was receiving favorable
reviews, to arrange for an exhibition of
his prints at the New School for Social
Research in New York.

1947

A fire destroyed Yunkers's Stockholm studio and ten years' work was lost. Later this year the artist exhibited at the Tokantens Kunsthandel in Copenhagen. In the summer Yunkers moved to the United States with Bergstrom and began teaching at the New School for Social Research. Henry Kleeman, his first dealer, sold prints to Lessing J. Rosenwald and John D. Rockefeller III. Yunkers's prints gained fame in America through several solo exhibitions in New York and group exhibitions at the National Academy of Fine Arts and the Pennsylvania Academy of the Fine Arts, both in Philadelphia. Leading American museums began to acquire his work, including the Metropolitan Museum of Art and the Museum of Modern Art in New York. He met Dore Ashton at the New School, where she was his student.

1948

Yunkers exhibition at Louis Hahne Galleries in Stockholm (prints and tapestry). Yunkers participated in group exhibitions at the Brooklyn Museum and the Minneapolis Institute of Arts and was given a solo exhibition at the Philadelphia Art Alliance. Yunkers took a summer job at the University of New Mexico in Albuquerque, where he bought land in the desert and built an adobe house and studio. He returned to New York for the winter, and for the next five years he spent summers in New Mexico and winters in New York.

1949

Yunkers received his first John Simon Guggenheim Fellowship. Throughout the year he participated in group exhibitions at the Museum of Modern Art in New York, the Corcoran Gallery of Art in Washington, D.C., and the Pennsylvania Academy of the Fine Arts. In the summer Yunkers tried to establish an art academy called the Rio Grande Workshop in Albuquerque. With his students at the University of New Mexico he published *Prints in the Desert*, an entirely handmade portfolio that was intended to help fund the workshop. The workshop never got off the ground.

1950

Yunkers made intermittent visits to New York, San Francisco, and Los Angeles, and exhibited his prints at the Corcoran Gallery of Art in Washington, D.C. Yunkers's father died in Germany.

1952

Yunkers contributed a portfolio of five prints to the Rio Grande Graphics project in Corrales. An advertisement for the project stated its aim: "Rio Grande Graphics believes that every home can have a museum without walls composed of the finest original prints available in America." Three portfolios in the Rio Grande Graphics series were published by Ted Gotthelf and edited by Dore Ashton, then print editor of *Art Digest*.

Yunkers's house was flooded twice and a great number of print editions and woodblocks were destroyed. He left New Mexico and resettled in New York. He divorced Bergstrom and married Dore Ashton, his fifth wife.

1953

Yunkers cut and printed *Polyptych*, a five-panel color woodcut measuring fourteen feet long. Just before *Polyptych* was to be shown at the Grace Borgenicht Gallery in New York, the ceiling of his studio caved in, destroying most of the edition. Yunkers worked quickly to reprint what was lost, and the show was a huge success.

In December he became an American citizen.

1954

Yunkers received a renewal of his Guggenheim Fellowship, enabling him to move to Rome with Ashton.

1955

Yunkers created the *Ostia Antica* series and enjoyed a series of solo shows in Europe: Rome, Paris, and London, among other cities. He also showed his work at the Grace Borgenicht Gallery in New York. He returned to New York to teach at the Cooper Union, where he would remain for the next eleven years.

In the fall Ashton became art critic at the *New York Times*. Through her, Yunkers became involved with the Abstract Expressionist movement.

1956

Yunkers was represented in the exhibition *Ten Years of American Prints, 1947–1956* at the Brooklyn Museum.

1957

In the spring Yunkers exhibited his early small pastel and charcoal sketches at the Grace Borgenicht Gallery and the Rose Fried Gallery in New York. Yunkers and Ashton vacationed in Spain, where he saw paintings by Francesco Goya and met with painters Antonio Saura and Antoni Tàpies. When the couple returned to New York, Yunkers began his landmark pastel series *Tarrassa*, the first pastels ever to be done on such a large scale.

1958

Yunkers began *Bewitcher's Sabbath*, a series of pastels inspired by Goya. To produce this series he drew small gouache sketches in the summer and converted them to large pastels in his New York studio in the winter.

1959

Yunkers and Ashton vacationed in Martinique and Guadeloupe in the West Indies. The trip inspired Yunkers's series of pastels titled *Gosier* or *Guadeloupe*.

1960

Yunkers exhibited his pastels at the Rose Fried and André Emmerich galleries in New York and at the Baltimore Museum of Art. He and Ashton visited the Venice Biennale. In the fall Yunkers participated in the Tamarind Lithography Workshop in Los Angeles, where he spent six weeks exploring the full potential of lithogra-

Photograph by Renate
Ponsold Motherwell of Yunkers
and Dore Ashton, 1973.
Courtesy of the Estate of Adja
Yunkers.

MY STUDIO ON 129 FRONT ST. WHERE THIS AND
OTHER BOOKS WERE CREATED AND WHERE I LEAR-
NED TO ACCEPT MY IMPENDING BLINDNESS AND
HAD TO GIVE UP PAINTING LARGE CANVASES •
 1982

Yunkers in his New York
studio, early 1980s.
Page from a scrapbook.
Museum of Modern Art,
New York.

phy. He created the *Salt* and the *Skies of Venice* series of prints.

1961

Yunkers won a bronze medal for the pastel *Darkfruit* at the 65th Annual American Art Exhibition at the Art Institute of Chicago.

1962

Yunkers made his last known great pastel, *Le Paysage aux Alouettes*, and abandoned pastel as a medium. His latest pastels were included in a retrospective of his work at the Stedelijk Museum in Amsterdam. The Yunkerses bought a house in Manhattan.

1964

Yunkers was appointed visiting lecturer at the University of Hawaii, Honolulu.

1966

Yunkers was commissioned to paint a large mural for Syracuse University, New York, titled *A Human Condition*. Ashton wrote that it was "a comment on his feelings of revulsion over the Vietnam War."

1967

Yunkers was commissioned to create a twelve-by-fifty-foot tapestry for Stony Brook University, Long Island, New York. He began the *Aegean* series, one of which was included in the portfolio *Artists and Writers against the War in Vietnam*.

1968

Yunkers briefly taught at the University of California, Berkeley, and was a visiting critic at Columbia University.

1969

Yunkers joined the art faculty at Barnard College. A retrospective exhibition of Yunkers's work at the Brooklyn Museum established his prominence in American printmaking. Yunkers collaborated with Paz on *Poems for Marie José*.

1970

Yunkers had his first exhibition at Estudio Actual in Caracas, Venezuela. Yunkers's mother, Adelina Junkers, died in August. Yunkers was reunited with his brother, Bruno (who had come to America in the 1950s), at her funeral in North Olmstead, Ohio. Bruno was killed in an accident in 1971.

1972

Yunkers exhibited at the Whitney Museum of American Art with success.

1974

Yunkers was awarded a gold medal for the lithograph *Sopratutto* at the Second International Print Biennial in Norway, and he had a solo show at the Zabriskie Gallery in New York. He collaborated with poet and friend Octavio Paz to create *Blanco*, a volume of fourteen illustrated love poems.

1975

A retrospective exhibition of Yunkers's work was shown at the Museo de Arte Moderno, Bosque de Chapultepec Instituto Nacional de Bellas Artes, Mexico.

1977

Separated from Ashton, Yunkers moved to a studio near the East River in lower Manhattan and isolated himself from galleries and artists.

1978

Yunkers created *To Invent a Garden*, referring, he said, to memories of his mother's garden in Petrograd. Late this year he moved to San Francisco.

1979

Yunkers was given a major show at the Museo de Bellas Artes in Caracas, Venezuela.

1980

Yunkers returned to live in New York.

1981

With his left eye already damaged by a calcification of the optic nerve, Yunkers became blind in his right eye. His poor eyesight, aggravated by emphysema, made painting extremely difficult.

1982

Yunkers completed his last large paintings. He would only be able to make small collages from this time on. He exhibited his prints in a major show at Albion College, Michigan, and Miami University, Oxford, Ohio.

1983

Yunkers spent the last months of his life largely in isolation in his Manhattan studio. On December 24 Adja Yunkers died of a severe respiratory attack in Beekman Downtown Hospital. A memorial service was held at CDS Gallery in Manhattan.

1984

A Yunkers retrospective opened at the Fine Arts Museum of Long Island, Hempstead, New York.

Note

Information for this chronology was compiled from the extant Adja Yunkers literature, most extensively from the manuscript of the present publication and William H. Robinson, "A Cloud in Pants, Adja Yunkers: Icons to Abstract Expressionism" (Ph.D. diss., Case Western Reserve University, Cleveland, 1998). Also helpful were the following publications: David Acton, *Adja Yunkers: Paintings, Drawings, and Prints, 1940–1983* (New York: Associated American Artists, 1990); *Adja Yunkers* (Cambridge: Hayden Gallery, Massachusetts Institute of Technology, 1973); *Adja Yunkers: The Life of Forms, The Mystery of Spaces* (New York: Associated American Artists, 1994); Dore Ashton, "Response to the Crisis in American Painting," *Art in America* 57 (January–February 1969); Anja Brand, "Un artiste proletarien: Adja M. Yunkers," *Monde,* November 30, 1929; Adelyn D. Breeskin, "Adja Yunkers— Pioneer of the Contemporary Color Woodcut," *Baltimore Museum of Art News* 16 (June 1953); Edward B. Henning and Scott Burton, *Adja Yunkers* (Salt Lake City: Utah Museum of Fine Arts, 1969); Kenneth B. Sawyer, "Means and Meanings: Adja Yunkers," *Arts and Architecture* 74 (March 1957); and letters from Lilly Nilsson Yunkers to Madlain Yunkers, 1984.

Selected Solo Exhibitions

1922–48

Maria Kunde Galerie, Hamburg

Galleri Moderne, Stockholm

Galleri Per, Oslo

Louis Hahne Galleries, Stockholm

New School for Social Research, New York

Norrköpings Konstmuseum, Sweden

Pottinger Gallery, Pasadena, California

Philadelphia Art Alliance

Tokantens Kunsthandel, Copenhagen

1949–53

The Art Institute of Chicago

Baltimore Museum of Art

Grace Borgenicht Gallery, New York

Buchholtz Gallery, Madrid

Colorado Springs Fine Arts Center, Colorado

Corcoran Gallery of Art, Washington, D.C.

Henry Kleemann Gallery, New York

Ministry of Education, Lisbon

Pasadena Art Institute, California

San Francisco Art Institute

1954–55

Grace Borgenicht Gallery, New York

Studio Paul Facchetti, Paris

Galerie d'Art Moderne, Basel

Galleria Numero Redazione, Florence

Göteborgs Konstmuseum, Sweden

Galeria Schneider, Rome

Zwemmer Gallery, London

1956–59

Grace Borgenicht Gallery, New York

André Emmerich Gallery, New York

Rose Fried Gallery, New York

Instituto de Arte Contemporaneo, Lima, Peru

Los Angeles County Museum of Art

Howard Wise Gallery, Cleveland

1960–70

Baltimore Museum of Art

Brooklyn Museum, New York

André Emmerich Gallery, New York

Estudio Actual, Caracas, Venezuela

Feigen Gallery, Detroit

Rose Fried Gallery, New York

Honolulu Academy of Arts

Malmquist & Wood Gallery, Cleveland

Stedelijk Museum, Amsterdam

Utah Museum of Fine Arts, University of Utah, Salt Lake City

1971–75

Carpenter Center for the Visual Arts, Harvard University, Cambridge

Estudio Actual, Caracas, Venezuela

Hayden Gallery, Massachusetts Institue of Technology, Cambridge

Impressions Workshop, Boston

Imprint Gallery, San Francisco

Instituto Nacional de Bellas Artes, Mexico City

Kent State University, Ohio

Langsam Gallery, South Yarra, Australia

Lantern Gallery, Ann Arbor, Michigan

Hellen Mazalow Gallery, Toronto

Museo de Arte Moderno, Chapultepec, Mexico

Nielsen Gallery, Boston

Phoenix Art Museum, Arizona

Smith-Andersen Gallery, Palo Alto, California

Smith-Andersen Gallery, San Francisco

Stedelijk Museum, Amsterdam

Whitney Museum of American Art, New York

Zabriskie Gallery, New York

1976–83

Albion College, Michigan

Allrich Gallery, San Francisco

American Academy in Rome

CDS Gallery, New York

Daedal Fine Arts Gallery, Baltimore

Estudio Actual, Caracas, Venezuela

Fairweather Hardin Gallery, Chicago

Impressions Gallery, Boston

L'Isola Gallery, Rome

Miami University, Oxford, Ohio

Museo de Bellas Artes, Caracas, Venezuela

Nielsen Gallery, Boston

Philadelphia College of Art

Simsar Gallery, Ann Arbor, Michigan

After 1984

Associated American Artists, New York (1988, 1990, 1994)

CDS Gallery, New York

Fine Arts Museum of Long Island, Hempstead, New York

Glenn Horowitz Bookseller, Easthampton, New York

Museum of Modern Art, New York

Painting Center, New York

Selected Public Collections

Albright-Knox Art Gallery, Buffalo, New York

Allen Memorial Art Museum, Oberlin College, Ohio

Art Museum, Princeton University, New Jersey

Baltimore Museum of Art

Bayly Art Museum, University of Virginia, Charlottesville

Bibliothèque Nationale de France, Paris

Bibliothèque Royale Albert, Brussels

Brooklyn Museum of Art, New York

Carnegie Museum of Art, Pittsburgh

Cleveland Museum of Art

Corcoran Gallery of Art, Washington, D.C.

Detroit Institute of Arts

Fogg Art Museum, Harvard University Art Museums, Cambridge

Fundación Museo de Arte Moderno, Ciudad Bolívar, Venezuela

Georgetown University Library, Washington, D.C.

Göteborgs Konstmuseum, Sweden

Solomon R. Guggenheim Museum, New York

Hamburger Kunsthalle

Hirshhorn Museum and Sculpture Garden, Smithsonian Institution, Washington, D.C.

Jewish Museum, New York

Johannesburg Art Gallery, South Africa

Library of Congress, Washington, D.C.

Los Angeles County Museum of Art

Metropolitan Museum of Art, New York

Minneapolis Institute of Arts

Minnesota Museum of American Art, St. Paul

Museo de Belles Artes, Caracas, Venezuela

Museum of Fine Arts, Boston

Museum of Fine Arts, Springfield, Massachusetts

Museum of Modern Art, New York

National Gallery of Art, Washington, D.C.

New York Public Library

Norrköpings Konstmuseum, Sweden

Pennsylvania Academy of the Fine Arts, Philadelphia

Philadelphia Museum of Art

J. B. Speed Museum, Louisville, Kentucky

University Art Museum, University of New Mexico, Albuquerque

University of Michigan Museum of Art, Ann Arbor

Victoria and Albert Museum, London

Walker Art Center, Minneapolis

Whitney Museum of American Art, New York

Writings by Adja Yunkers

To paint, for me, is an intimate affair and therefore difficult to speak about—not to mention the impossibility of explaining "IT" or the "It-ness" of it: the subject matter in its essence as experience.

I abhor "explaining" post feastum what my intentions were, once the picture is a reality; to want to speak about one's conceptions and intentions is humanly understandable but to me a gruesome post-mortem. If the painting does not "explain itself" and convey the experience to be derived from it, surely no words will do it. I like to think of Rembrandt's "Jewish Bride" in which the bridegroom reaches out for the heart of his beloved. His hand barely touches her breast—but what about the time and space between that hand and that heart? There is the true drama and I hate to think of "explanations" that will not in any case be able to explain the innertness.

However—my perversity lies in the fact that I do enjoy committing my crimes privately in the intimacy of my monologues and, if possible, getting away with them.

What Melville said about the sea also applies to the artist: "... it is not a vista but a background. People living on it experience it in the foreground."

And to conclude these lines I would like to quote one of the fathers of the church, Origen, who said: "Experts in the use of charms tell us that if we pronounce a given spell in its own language it can bring about the effect that the charm professes to do; but if we translate it into another language it will be found to be weak and ineffective."

That, I believe, covers effectively what I was trying not to say.

**Text for the Invitation to an Exhibition
at the Centro de Arte Contemporáneo,
Caracas, Venezuela, March 1977**

Once upon a time there was

A hermit who always carried

About him a Pot containing

A peck of rice.

At Night he slept in the

Pot.

Some Times

The pot changed into the Uni

Verse with the Sun and

Moon in it.

And

He called the pot "pot Heaven"

And he himself was known as

Mister Pot.

in
 Fall
woods hone
downward,
bone dry,
 wait
inward—
earth frail,
as man
the doubt
dropping wisdoms...

our white
will come.

September 1980

Mass

astonishing!
goose tree
top honk
whooping/my
god the
place sounding
ponds:
while
elsewhere
 shooing
 sigh

 soft
leaf blood red,

 Summer
goes.

September 1981

snow clouds

today:
the quiet
grave bellies,
their host cortege,
the cold
gray distance,
shadow

our winter
home.

October 1981

ark

Winter:
alone
drifts slowly—

December 1981

gaunt

Winter settles;
haunting autumn
gone

long
nocturnal voyage,
alone

my slowly
drifting
on.

December 1981

Ancestral

Soundless
 the
 falling
drifting
 down
 slowly

 a
 river source
the deathwatch
isle—
 aimless
 deep
 flowing,
about
 me . . .

some days
begin this
way:

dust over my eyes
 —Birdmoon
bone yellow
the lid
cold shuddering
and brief,
floats
my heart—

this blind
eternity.

Summer 1982

yesterday,
 today
 these
 old—
 curious
endless
roads

January 31, 1983

Spring

An
ancient tree

haggard,
withered limb

bends.
A waiting giving—
again,

a further
sun.

Easter, 1983

Shape of Knowing

In
delicate
thin need
as wind
 world
 our,
articulate flute—
stone against
self

thrown is
man.

May 1983

forget-me-not

a
 pale
 astral
mouth,
skull and bloom

drying
 river,
 entering
aging
sea

we wait
 and
 dream,
well
inroad path

enclose
 eter-
nity.

June 1983

I Am—A Litany

I am the raindrop skating busily down

the window pane

I am the cut navel string looking

for a connection.

I am the timeless half of women giving

birth.

I am the fault in a perfect pearl.

I am the closet filled with dusty phan

toms I inherited from my father.

I am the scream of a newborn babe.

I am the hollow in god's hand.

I am the pitiful look in a horse's eyes

before being shot,

I am a ripple in the desert sand,

I am the resignation and pain of the

nameless forgotten street people,

I am the guardian of pain,

I am the lust and the boredom,

I am the blind man led by a blind man,

I am the buzz of a horsefly,

I am the miracle—an artist.

I am the unimaginable,

I am unique,

I am the blessing,

I am the beauty and the ugly,

I am a mansion of love,

I am the unwritten, undelivered,

I am the camel

Whose back was not broken

I am most definitely the "not to be"

BECAUSE I AM HUMAN.

early 1980s

I Know: A Quasi Biography*

I know of many things, of li-
ving and the many ways of dying,
of magnificent parks and dark
alleys, of the times of the horse
and those of the butterflies, of swa-
ns and the lakes and the birds in the
skies, of the lowly gray sparrows in
big cities, of cyclones and terrifying
hurricanes on land and sea, of the
sun and the moon and of walking
the milky way. Of tears and lau-
ghter and the sneeze. Of love

and despair, of pathos—the long-
ing for the absent, of loyalty and des-
pair, of betrayal, of heartbreaks
and hope eternal, of happiness bro-
ught by a brilliant ray of sunshine
on the highly polished living room
floor and the smell of freshly baked
bread on a Sunday morning. Of bar-
ricades in the streets of big cities, and
of tear gas and nightsticks and of split
skulls, and pools of blood, of democra-
cy betrayed and fascism in-

stalled and supported by the
"great democracies." I know of the
flights into danger misna-
med "courage" or "heroism," and of
many things unspeakable.

I know of the ways of the sea and
those of the wandering desert, both
hungrily, everlastingly reaching
for a shore and never succeeding.
I know of the morning dew on
desert flowers and the expectant deep
breathing of the desert at night, like
an enormous spider, waiting, wai-
ting. I know of the desert in bloom
making believe to be a Persian carpet
and of man's windswept foot prints.
I know of the dark hearts of moun-
tains I never climbed, but could feel
—at times, their heartbeat on a clear
day, I know of awesome pyramids
in Yucatan and of the truckloads of
flies swarming, climbing all over
them, like the Egyptian plague.

I know of the hazard innate in
self propelling objects in the skies,
of machines created for profit-ma-
king and robbing man of his digni-
ty and of the beastliness of inanima-
te things. Of fires bursting out of
walls and ceilings that fall on
sleeping people. I know of beach-
combers, stow-aways, and the hell in
the bellies of ships, of pick-pockets, and
thieves, and those thieves in the social
register, of honors and medals be-

stowed on criminals, of corruption
and of buying of seats in heaven,
I know of various ways of sleeping
Of the difference between a wooden
and that of a marble one, of sleeping
on week-ends in leaking tents, called
"guest-rooms," of sleeping under
the stars and in luxury hotels, of
sleeping in whorehouses, in door-
ways and in anemic, desolate rail-
road waiting rooms, in brick-making
ovens still warm from the day's work,
. .
Living I paid not much attention to
concentration, discipline and purpo-
sefulness, of the true great artists.
Like the bull in the arena I did choose my
Querencia, the place chosen from
which he is going to give battle, and what
a glorious battle it has been. Yes.
Having left my parents' home at a
very early age, like a stammerer learning
to speak coherently, I had to learn, pain-
fully, the meanings of "right" and of
"wrong" and how to fit in a civilized so-
ciety and I am not sure that I've learned
this one properly, not yet, although from
the beginning I had an exaggerated sense
for "justice," being an artist did not pre-

clude the moral dictum of also being a
social animal.

The turbulence, the political upheа-
vals, the incredible years of starvation
of peoples in Europe between the two world
wars, was not exactly a place "pour une
Education sentimentale." A stable society,
calm, peace, security—etc. were terms un-
known but hoped for to possess. Settling
in America, was a traumatic experience,
Orderliness, effectiveness, innocence, gene-
rosity, hospitality, the kindness of indi-

viduals, the love and warmth extended
to me, were all very intoxicating and
a sort of nirvana, at first. Things have
changed since then. However—the fact
I could find a place big enough for my
feet to stand on, a place of my own and
the certainty that tomorrow it still would
be there, the sense of security it gave
to me—I had never before experienced
in my life. Yes—America has been good to me.
There are many serious things I

did not mention in these pages, but
they are well kept in the folds and
lining of my well worn soul.
All said and done being no more
than a buzz of a horsefly and at best
a footnote to history.

New York City, 1983
*This transcription copies Yunkers's spelling
and line endings.

134

Selected Bibliography

Statements and Interviews with Yunkers

Interview. 1968. Archives of American Art, Smithsonian Institution, Washington, D.C.

Interview by Paul Cummings. 1969. Archives of American Art, Smithsonian Institution, Washington, D.C.

Interview by William H. Robinson. 1969. Archives of William H. Robinson.

Yunkers, Adja. "Adja Yunkers." *Tiger's Eye* 1 (June 15, 1949): 52–53.

————. Papers. Scrapbooks and letters. Portfolio and poetry books. Museum of Modern Art Library, New York.

————. "Statement." *Prints in the Desert*, no. 1 (1950): n.p.

————. "Statement." *It Is*, no. 4 (Fall 1959): 28.

————. "Statement." In *Contemporary American Painting and Sculpture*. Exhibition catalogue. Urbana: Krannert Art Museum and University of Illinois Press, 1961.

————. Transcript of a lecture presented at the Corcoran Gallery of Art, Washington, D.C., 1967. New York: Brooklyn Museum.

Books and Cataloque Essays on Yunkers

Acton, David. "Adja Yunkers." In *Adja Yunkers: Paintings, Drawings, and Prints, 1940–1983*. Exhibition catalogue. New York: Associated American Artists, 1990.

————. *A Spectrum of Innovation: Color in American Printmaking*. Worcester, Mass.: Worcester Art Museum, 1990.

Adams, Clinton. Introduction to *Adja Yunkers: Woodcuts, 1927–1966*. Exhibition catalogue. New York: Associated American Artists, 1988.

Adja Yunkers. Cambridge: Hayden Gallery, Massachusetts Institute of Technology, 1973.

Adja Yunkers: The Life of Forms, The Mystery of Spaces. New York: Associated American Artists, 1994.

Arnason, H. H. *American Abstract Expressionists and Imagists*. Exhibition catalogue. New York: Solomon R. Guggenheim Museum, 1961.

————. *History of Modern Art: Painting, Sculpture, Architecture*. New York: Harry N. Abrams, 1968.

Calas, Nicolas. Introduction to *Adja Yunkers*. Exhibition catalogue. New York: Whitney Museum of American Art, 1972.

Dorazio, Piero. "Adja Yunkers: Un Inventeur." In *Adja Yunkers*. Exhibition catalogue. Paris: Studio Paul Facchetti, 1955.

Flomenhaft, Eleanor. "Adja Yunkers: A Poem in Every Picture." In *Adja Yunkers: A Twentieth-Century Master*. Exhibition catalogue. Hempstead, N.Y.: Fine Arts Museum of Long Island, 1984.

Grohmann, Will. Foreword to *Yunkers: Color Woodcuts and Monotypes*. Exhibition catalogue. New York: Grace Borgenicht Gallery, 1955.

————. Introduction to *Yunkers*.

Exhibition catalogue. Göteborg, Sweden: Göteborgs Konstmuseum, 1955.

Henning, Edward B. *Fifty Years of American Art, 1916–1966*. Cleveland: Cleveland Museum of Art, 1966.

Henning, Edward B., and Scott Burton. *Adja Yunkers*. Exhibition catalogue. Salt Lake City: Utah Museum of Fine Arts, 1969.

Holten, Ragnar von. *Surrealismem i Svensk Konst*. Stockholm: P. A. Norstedt, 1969.

Hults, Linda C. *The Print in the Western World: An Introductory History*. Madison: University of Wisconsin Press, 1996.

Johnson, Una E. *Adja Yunkers: Prints, 1927–1967*. Brooklyn, N.Y.: Brooklyn Museum, 1969.

Leeper, John Palmer. Introduction to *Rio Grande Portfolio*. Corrales, N.M.: Rio Grande Graphics, 1952.

Mortensen, Richard. "Adja Yunkers." In *Adja Yunkers, Grafik*. Exhibition catalogue. Copenhagen: Tokantens Kunsthandel, 1947.

Robinson, William H. "A Cloud in Pants, Adja Yunkers: Icons to Abstract Expressionism." Ph.D. diss., Case Western Reserve University, Cleveland, 1988.

Sawyer, Kenneth B. "Adja Yunkers." In *Adja Yunkers: Recent Paintings*. Exhibition catalogue. Baltimore: Baltimore Museum of Art, 1960.

Smith, William Jay. *The Skies of Venice*. Exhibition catalogue. New York: André Emmerich Gallery, 1961.

Zigrosser, Carl. Introduction to *Adja Yunkers: Color Woodcuts, Monotypes*. Exhibition catalogue. Philadelphia: Philadelphia Art Alliance, 1948.

————. *Prints and Their Creators: A World History*. New York: Crown Publishers, 1974.

Articles

Alvard, Julien. "Adja Yunkers." *Cimaise*, no. 72 (February–May 1965): 32–39.

Ashton, Dore. "Adja Yunkers: His Prints." *Bulletin of the Pasadena Art Institute*, no. 2 (October 1951): 10–15.

———. "Pastel Anthology." *Arts Magazine* 31 (February 1966): 29–32.

———. "Print Project Launched." *Art Digest*, October 1, 1952, 10.

———. "Response to the Crisis in American Painting." *Art in America* 57 (January–February 1969): 24–35.

Bartelik, Marek. "Adja Yunkers." *Artforum* 35 (September 1996): 112–13.

Battcock, Gregory. "Adja Yunkers." *Arts Magazine* 42 (February 1968): 65.

Brand, Anja. "Un artiste proletarian: Adja M. Yunkers." *Monde*, November 30, 1929, 7.

Breeskin, Adelyn D. "Adja Yunkers— Pioneer of the Contemporary Color Woodcut." *Baltimore Museum of Art News* 16 (June 1953): 4–7.

Burton, Scott. "The Eye's Edge." *Studio International* 175 (March 1968): 203.

Calas, Nicolas. "Adja Yunkers." *Art International* 16 (October 1972): 42.

———. "Adja Yunkers." *Artforum* 13 (March 1975): 70.

Canaday, John. "Art: A Show That Fulfills Promises." *New York Times*, February 19, 1957, 19.

Clurman, Irene. "Exploring the Visual Equivalent of Silence." *Rocky Mountain News* (Denver), April, 21, 1983, 89 and 94.

Devree, Howard. "Adja Yunkers: Color and Poetry." *New York Times*, March 24, 1957, 19.

Fitzsimmons, James. "Print Polyptych." *Art Digest* 27 (May 15, 1953): 14.

Forge, Andrew. "Adja Yunkers." *Art International* 22 (January 1979): 36–38, 116–19.

Gindertael, R. V. "Yunkers." *Cimaise*, no. 7 (1955): 20.

Grant, Daniel. "On Art: Abstracts of Exquisite Color." *Newsday*, April 27, 1984, 2/19.

Henning, Edward B. "Adja Yunkers Revisited." *Art International* 14 (February 1970): 56–61.

———. "Untitled No. 2." *Bulletin of the Cleveland Museum of Art* 56 (February 1969): 68–71.

Leeper, John Palmer. "Adja Yunkers." *New Mexico Quarterly* 20 (Summer 1950): 191–95.

Linker, Kate. "Adja Yunkers." *Arts Magazine* 49 (March 1975): 52.

Oeri, Georgine. "Adja Yunkers, or the State of 'Irritable Richness.'" *Art International* 5 (November 20, 1961): 36–41.

O'Doherty, Brian. "Art: Adja Yunkers Show." *New York Times*, November 23, 1962, 59.

Paz, Octavio. "The Invitation of Space." Translated by Eliot Weinberger. *Art International* 22 (January 1979): 39–42.

Rosenberg, Harold. "The Philosophy of Put-Togethers." *New Yorker*, March 11, 1972, 117–18.

St. Pierre, Brian. "A Human Condition." *Ramparts*, October 1966, 58.

Sawin, Martica. "Adja Yunkers." *Arts Magazine* 31 (November 1957): 39–43.

———. "Adja Yunkers." *Arts Magazine* 34 (November 1959): 58.

Sawyer, Kenneth B. "Adja Yunkers." *Cimaise*, no. 47 (1960): 81.

———. "Means and Meanings: Adja Yunkers." *Arts and Architecture* 74 (March 1957): 16–17.

Selz, Peter. "Yunkers." *XXe Siècle* 24 suppl. (February 1962): 10–12.

Shattuck, Roger. "Blanco: A Poem by Octavio Paz; Illuminations by Adja Yunkers." *Craft Horizons* 35 (August 1975): 18–20.

Tallmer, Jerry. "Portrait of an Artist with No Strings Attached." *New York Post*, January 30, 1982, 12.

Wick, Peter A. "Gallery Reviews: Adja Yunkers: Phoenix in Boston." *New Boston Review* 1 (Winter 1975): 26–27.

Index

Photograph Credits